C000263657

DERWENT VALLEY MILLS
THROUGH TIME
Adrian Farmer

AMBERLEY

For Gwen Wilson and Sukie Khaira, who work so hard for the Derwent Valley Mills World Heritage Site; also Tony and Vicki Brown, Pippa Mansel and George Jones, Adam Lathbury and Becky Waddington, for all their support and friendship; and for all the people who work or volunteer to make the valley the great place it is, not least my ever-patient wife, Mary.

Dedicated to the memory of William Wellington Rowland, the grandfather I never knew, killed in action at Esquelmes, Belgium, in May 1940, seventy-five years ago.

First published 2015

Amberley Publishing
The Hill, Stroud, Gloucestershire, GL5 4EP
www.amberley-books.com

Copyright © Adrian Farmer, 2015

The right of Adrian Farmer to be identified as the Author of this work has been asserted in accordance with the Copyrights, Designs and Patents Act 1988.

ISBN 978 1 4456 1506 6 (print)
ISBN 978 1 4456 1515 8 (ebook)

British Library Cataloguing in Publication Data.
A catalogue record for this book is available from the British Library.

Typesetting by Amberley Publishing.
Printed in Great Britain.

Introduction

Derbyshire's Derwent has, for centuries, been a hard-working river, driving waterwheels and later turbines to power some of the most important mills in world history. The 15-mile stretch from Matlock Bath to Derby is now regarded as the birthplace of the modern factory, playing a key role in the earliest stages of the Industrial Revolution. The mass-production achieved here during the eighteenth century, and the legacy of mills and communities still with us today, deservedly earned inscription on UNESCO's World Heritage List in 2001.

Although the eighteenth and nineteenth centuries were the glory days for the Derwent Valley Mills, there was still growth before the slow decline of the twentieth century. The cover view is a good example, with the Belper mills seen from the River Gardens, firstly c. 1908 when the pleasure grounds were still new, with the 1854 chimney standing alone, and the West Mill's clock tower peeking out behind the North Mill. The modern view shows the chimney and clock tower have gone, but the mighty East Mill of 1912 has risen and can be seen beyond the bandstand – part of the final expansion of the English Sewing Cotton Co. in the valley.

Music has been part of Belper's River Gardens since their inception in 1906. The bandstand has been well used throughout its life – from early recitals, with listeners seated formally in a circle, to present-day summer concerts, with visitors sitting or standing where they like to hear all manner of musical entertainment.

A book of this size cannot cover every aspect of the Derwent Valley Mills and the communities around them, nor explain their significance (or even provide references). At best, it's a taste of what can be found between Masson Mills at Matlock Bath and Derby's Silk Mill as you follow the Derwent from north to south.

One area that does receive a little more coverage is Belper – partly because it's my home turf, but it also gives me a chance to celebrate the town's 2014 win in the national Great British High Street Competition. The judges were impressed with the Belper Ambassador training sessions, which help shopworkers to better understand the town and its history. The chance to look at the past of what is now officially Britain's best high street was too good to miss.

Of the challenges faced in developing this book, the greatest was taking the modern-day photographs – the growth in size and number of trees has had a considerable impact on several important historic views, although it's not just down to the trees. It's frustrating to have wonderful old images and not be able to use them. Equally frustrating, there are areas of heritage for which I can't find an old photograph!

For more on the World Heritage Site, a series of informative publications have been produced by the Derwent Valley Mills Educational Trust, the latest of which – *Cromford Revisited* – is a particular mine of information. There's also a website – www.derwentvalleymills.org. They're well worth seeking out, once this book has, hopefully, given you a taste for this fascinating, historic valley.

Acknowledgements

For guidance, information, photographs and proofreading, I'd whole-heartedly like to thank the following people: Mary McLean-Farmer, the late Tom Alton, Anthony Attwood, Ian Barlow, Annie Bird, Tony Bowker, Iain Campbell, Peter Davies, Heather Eaton, Christine Erratt, Richard Fletcher, Alan Foord, Don Gwinnett, Roy Hartle, Malcolm Hill, the late Marion Holden and family, David Jennison, George Jones and Pippa Mansel, Barry Joyce, Pam and John Lloyd, Sarah McLeod and the Arkwright Society, Jane Middleton-Smith and the John Smedley archivists, Patrick Morriss, Hugh Potter and the Friends of Cromford Canal, Richard Pinkett, Lin and Michael Ryan, Mary Smedley, Ben Spiller, Tim and Caroline Sutton, the late Eric Swain, Tim Tomlinson, Gwen Wilson and The Derwent Valley Mills World Heritage Site Research and Publications Panel.

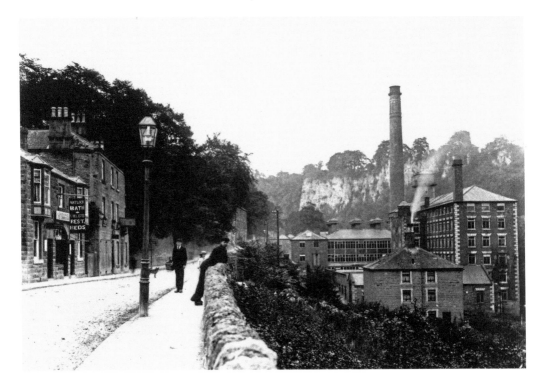

Masson Mills Before Expansion
The building of the later mills, and heightening and realignment of the road, make a modern interpretation of this view of Masson Mills virtually impossible, although there are similarities to the earlier photographs on page 7. The chimney of 1900 has been built, and the gassing mill (left of the chimney) modernised, but the cottage in the foreground has not yet been demolished for the building of the Glenn Mill in 1911. The buildings on the left were also demolished when the road was realigned.

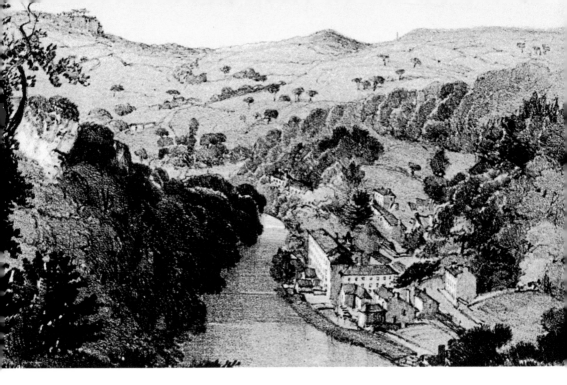

Masson Mills from Wildcat Crags

The Wildcat Crags above Matlock Bath provide a wonderful view into the Derwent Valley Mills World Heritage Site from the north, looking down on Sir Richard Arkwright's Masson Mills by the river. The addition of the chimney and, beyond, the larger mills with tower, make the cluster of buildings look quite different today, compared to the mid-nineteenth-century print above. At the top left you can now also see the expanded village of Cromford and nearby quarries.

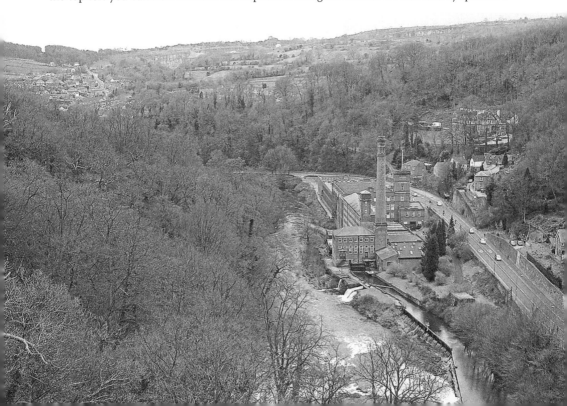

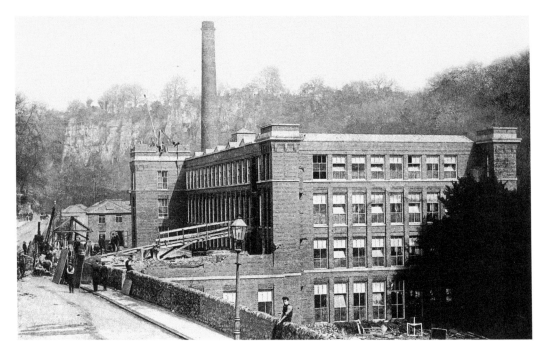

Building the Masson Tower

In 1911, the English Sewing Cotton Co. – an 1897 amalgamation of fourteen companies, including the Arkwright and Strutt empires which transformed textile production in the eighteenth century – brought further investment to its mills at Masson. Above, the Glenn Mill is nearing completion, while the tower is taking shape. As can be seen from the modern view below, a further mill was built, now used as a car park for the shopping village housed in the Glenn Mill.

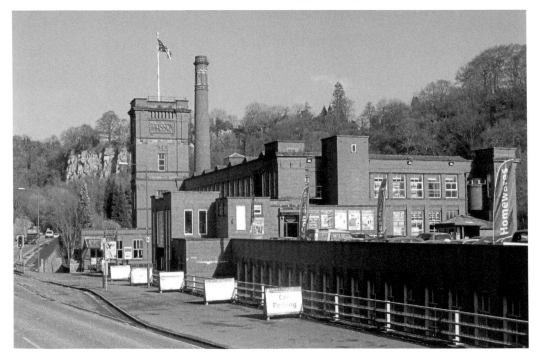

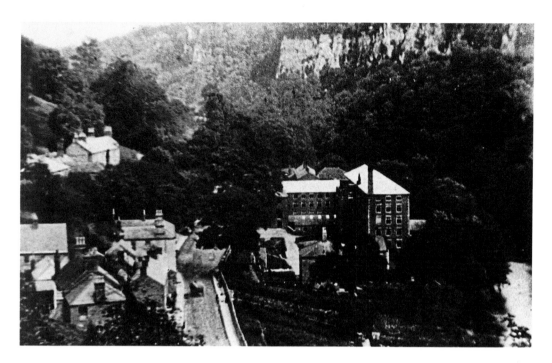

Masson Mills from Harp Edge

The view from Harp Edge is opposite to that on page 5 from Wildcat Crags. Between the 1880s view (*above*) and the one below (from a postcard used in 1905), you can see the differences introduced by architects Stott & Sons in 1900, at a cost of £4,859. The chimney alone cost £600. It is impossible to take the same view today, as Harp Edge is a mass of trees – you need to get much closer to see anything of the mills (*see inset*), and even then the newer additions hide the older mill of 1783.

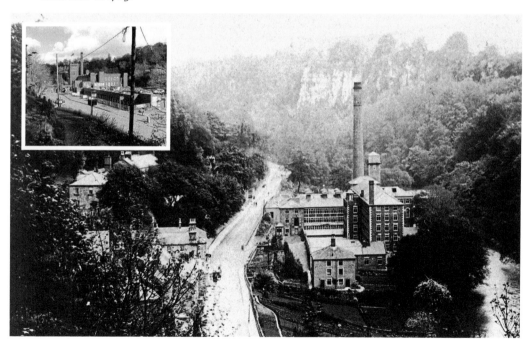

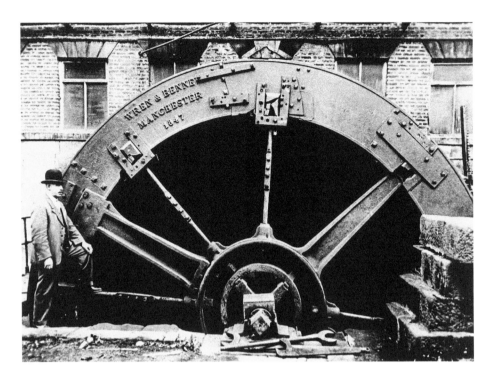

Water Power at Masson

Water is still an important source of power along the Derwent Valley, and an integral part of the World Heritage Site's story. It was the untiring power from waterwheels that allowed mass-production on a scale unheard of in Derbyshire's eighteenth-century mills. The 1847 waterwheel at Masson is pictured above shortly before it was replaced with the more effective turbines. The turbine houses at Masson today are less impressive than the wheel but provide all the power the mills need – and more.

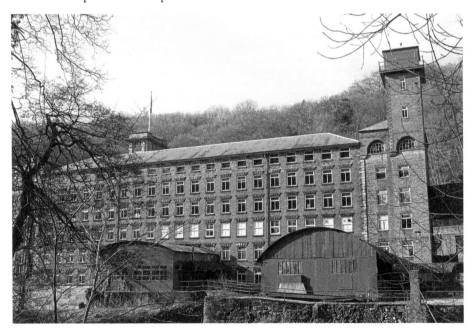

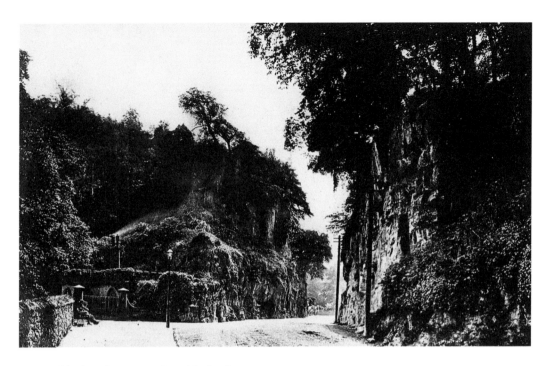

Widening the Gap at Scarthin Rock

On numerous occasions over the past three centuries, the route through Scarthin Rock at Cromford has been enlarged for easier passage. At the beginning of the twentieth century (*above*), the road was still much narrower than it is today. On the left, by the gates, you can see a little lodge for Willersley Castle, now demolished. The smoke seen here in the modern view is from miniature traction engines (*seen more clearly inset*) passing through during the annual World Heritage Site Discovery Days Festival, held every October.

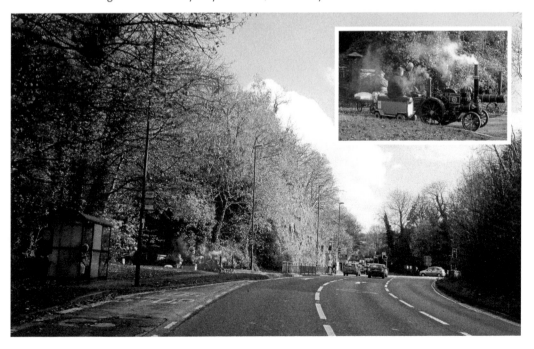

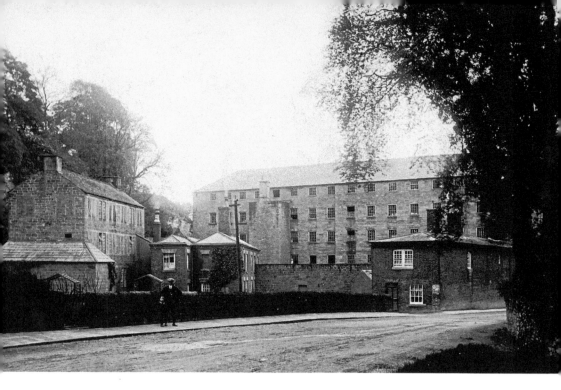

Arkwright's First Water-Powered Cotton Mill

The postcard view above (postally used in 1910) show's Richard Arkwright's first water-powered cotton-spinning mill at Cromford, already much changed since 1771 – the year it was built. In the second photograph, the loss of the top two storeys is evident – the result of a fire in 1929, while the site was being used as a colour works. The roof to Grace Cottage, on the right, has been significantly altered in the past century.

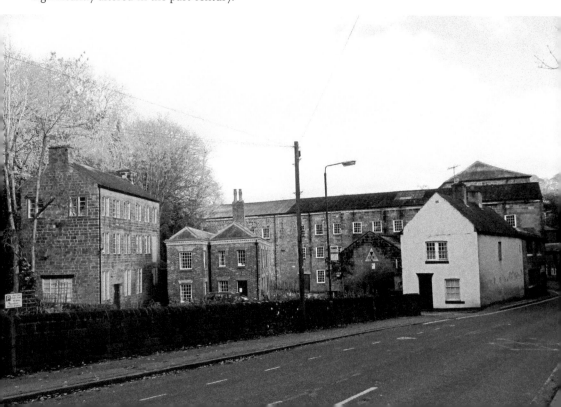

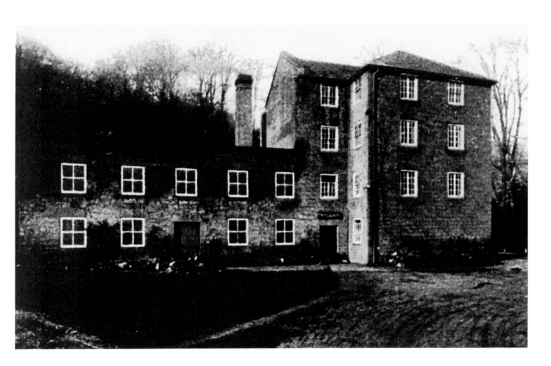

The Troy Laundry

After Arkwright's second mill at Cromford was destroyed by fire in 1890, the surviving extension was leased out as a laundry from 1895. Since the 1924 image above was taken, the boiler house chimney has been demolished and the former link building to the second mill much altered (*left*). The facing bay on the right looks unchanged, thanks only to a full restoration by the Arkwright Society to remove a three-storey extension built between the wars.

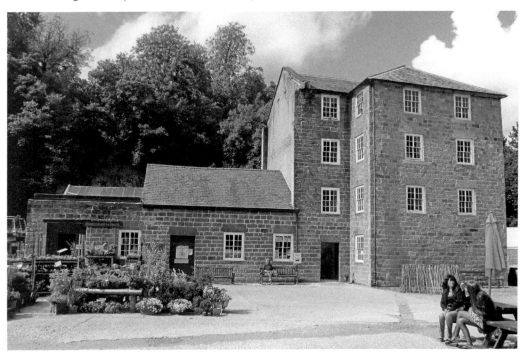

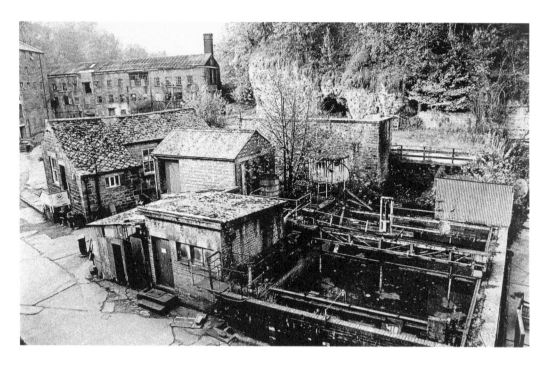

Restoring Arkwright's Cromford Mill

When the Arkwright Society purchased the mill site (the colour works in 1979, and the rest in 1988) they took ownership of a considerable number of buildings in the mill yard, relating to its later uses. Now, thanks to a massive programme of restoration work, the later additions have gone and the surviving industrial heritage can be more clearly read, including the remains of the second mill in the foreground. The viewing platform allows a fascinating look down into the second mill wheel pit, which had been covered over and hidden by previous owners.

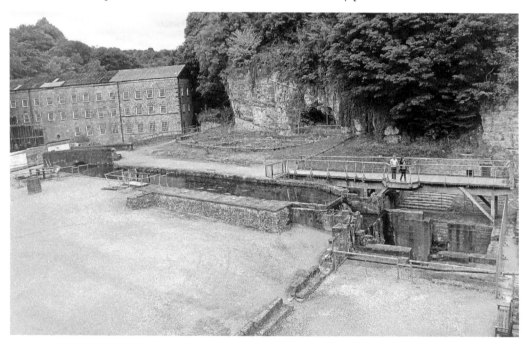

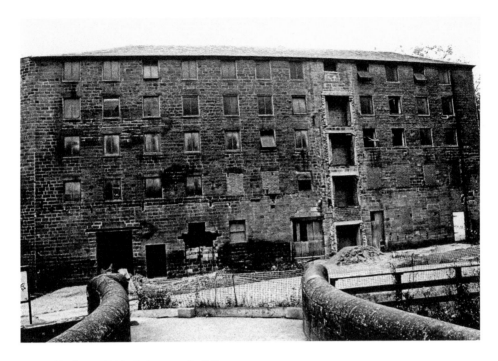

New Life for Mill Site's Largest Building

Built in 1783, this five-storey building within the Cromford Mill complex is the biggest on site, and has proven to be the largest restoration project so far for the Arkwright Society. It was heavily contaminated from its use as part of the colour works. Later additions like the lift shaft had to be removed for the building to be returned to its former simple and functional elegance. Now, with appropriate windows and fully decontaminated, it will shortly become a visitor centre for the Derwent Valley Mills World Heritage Site, with business units above.

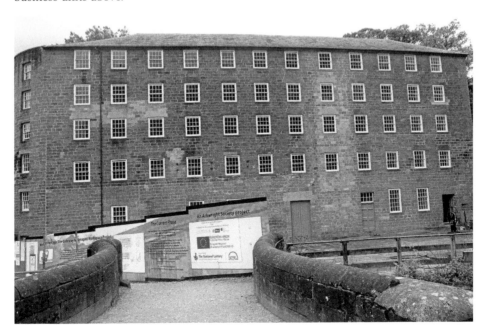

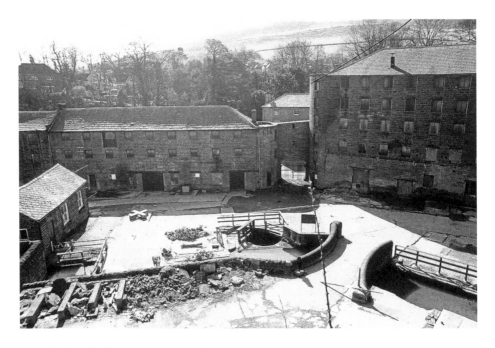

Cromford Mills from Scarthin Rock

This view of a partly cleared mill yard at Cromford in the 1980s was taken from Scarthin Rock, which towers over the buildings. The later photograph shows how shops have been inserted into the buildings, and the yard cleared to better display the water course, but the growth in vegetation on Scarthin Rock reduces the impact. DerwentWISE, a scheme funded with Heritage Lottery money, is currently enabling landscape restoration work to take place across the World Heritage Site, including here, where vegetation will be cut back so the view can be enjoyed.

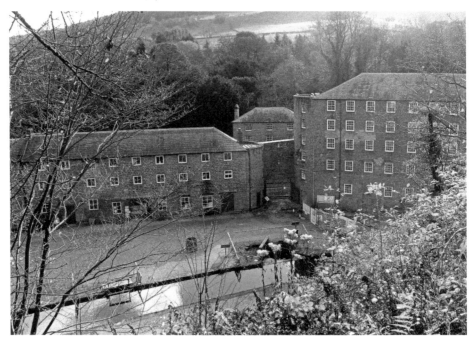

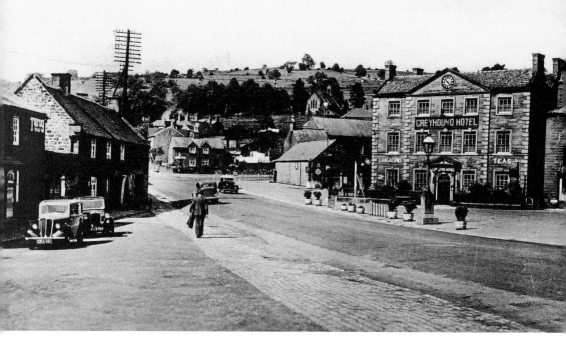

Cromford Market Place

Shortly before the Second World War, Cromford clearly had far fewer motor vehicles passing through than it does today. The proximity to open countryside must have made the provision of luncheons and teas for ramblers a worthwhile exercise for promotion by the Greyhound Hotel. On the hill beyond, you can see St Mark's chapel, consecrated in 1877 but demolished in 1970. The stone setted footway in the foreground is an attractive feature in the older photograph. Since then, trees have replaced telegraph poles to tower over the rooftops.

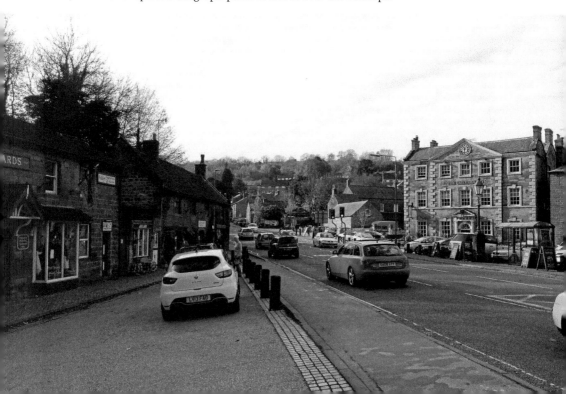

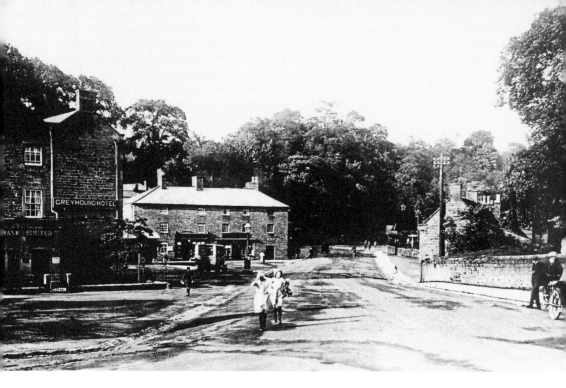

Cromford Market Place, Looking North-East

This view, looking back towards the road junction with the A6, highlights the increase in street clutter – road signs, advertising, traffic lights and chained posts have impacted on the simplicity of the scene. The earlier view reveals the presence of a branch office for Lloyd's Bank Ltd within the Greyhound Hotel building before they moved across the road to No. 29. Beyond the Greyhound and just visible is the single-storey Georgian 'shambles' – originally butchers' shops – still in use today.

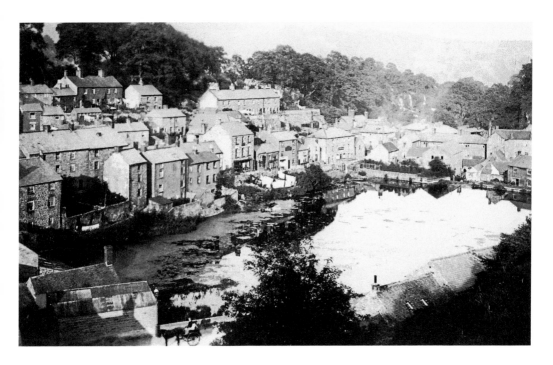

Scarthin and the Greyhound Pond

Behind the Greyhound Hotel is the Greyhound Pond, which stored water for the mills. It's impossible to replicate the earlier view, as housing covers the bank where the photographer once stood. Undoubtedly the best known landmark here is Scarthin Books, opened in 1973. On the older image the building is the three-storey block with washing outside. You can glimpse the shop on the present-day image, on the far left. Next door is the former Mount Tabor chapel, built before the First World War but after the earlier photograph.

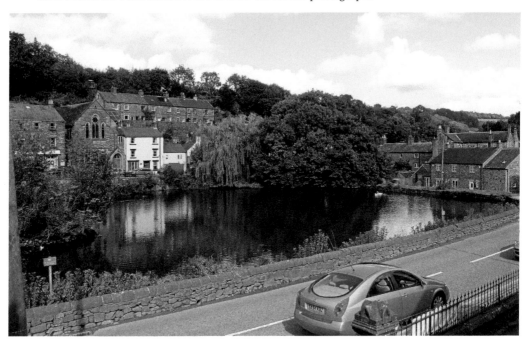

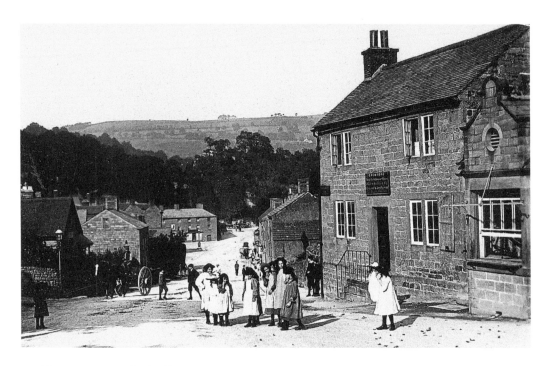

Looking Down Cromford Hill

The former Cock Inn on Cromford Hill is on the right. No longer a public house even when the older photograph was taken in the early twentieth century, it describes itself as 'refreshment rooms' in the sign above the door. The building is relatively unchanged in the modern view, although the frontage has been softened and partly concealed by planting, disguising its former public use. A new plaque with the date '1730' is fixed to the wall. Children were once able to play in the road, whereas it's now rather dangerous to photograph from the same spot.

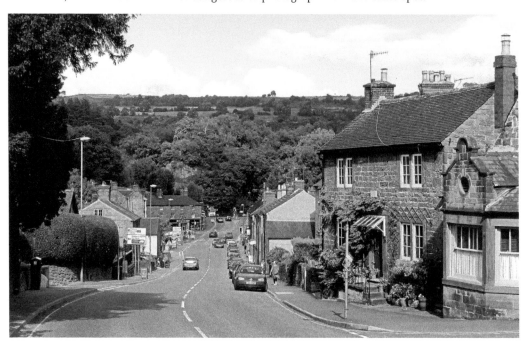

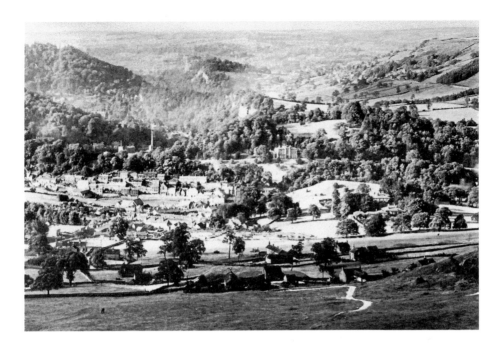

Cromford from Black Rocks

Black Rocks offer a wonderful viewpoint for looking at Cromford, Masson Mill with its chimney, and Willersley Castle. Cromford, and Matlock in the distance, have grown considerably since the earlier image, taken between the two world wars. Yet from this distance, the green valley setting for the mills and their communities is still clearly there. The World Heritage Site's Statement of Outstanding Universal Value – the key document that explains its global significance – highlights the importance of this surviving rural landscape as a contributory factor in the inscription on the UNESCO World Heritage List.

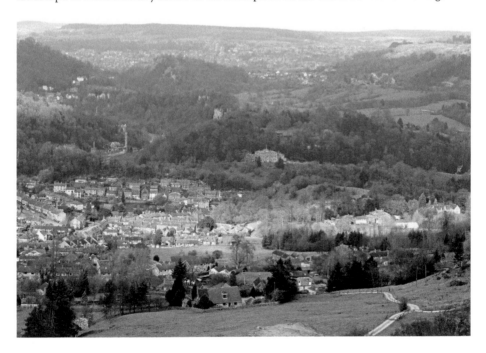

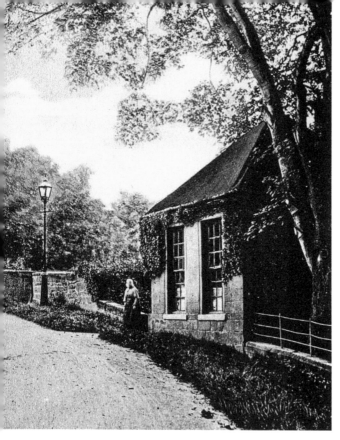

Fishing Lodge by the Derwent

This fishing lodge, nestling by the old bridge across the Derwent at Cromford, is still in use by the local angling club. There is an inscription over the door, *'piscatoribus sacrum'* – sacred to fishermen. The earlier view shows the little building when it was being used as a cottage; below and to the left of it are the remains of a medieval bridge chapel. On the wall, close to where the chevron sign is now secured, is an inscribed stone (*inset*) commemorating the Leap of Mare in 1697. This is believed to relate to the tale of Benjamin Hayward of nearby Bridge House, whose horse failed to take the bend and leapt over the parapet, plummeting into the river below. Both survived the fall!

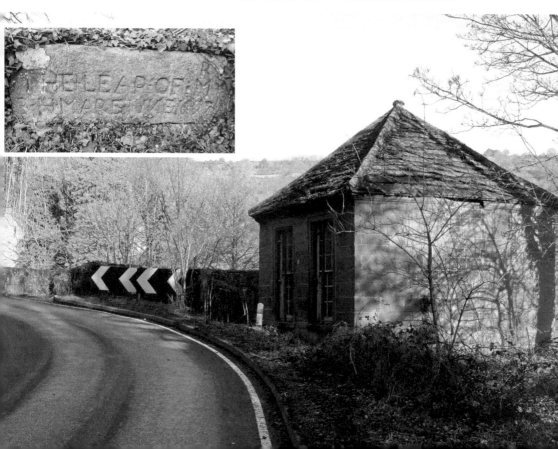

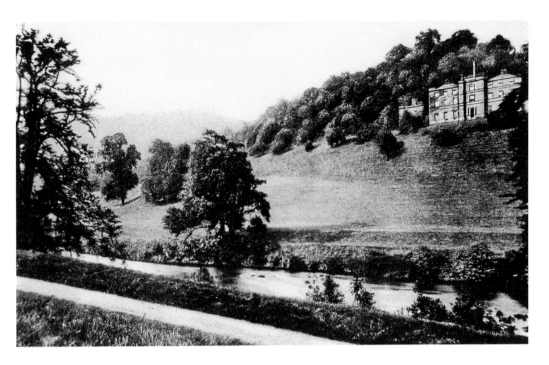

Willersley Castle from Church Walk

Church Walk runs between Scarthin Rock and the River Derwent, from the former lodge site (*seen on page 9*) to St Mary's church. It once gave very clear views across the river to Willersley Castle – Arkwright's mansion (although not finished until after his death in 1792). Today, it's almost impossible to see the house, even in winter, as trees line the river. The Arkwright Society has an aspiration for greater management of these trees, allowing the view to be restored.

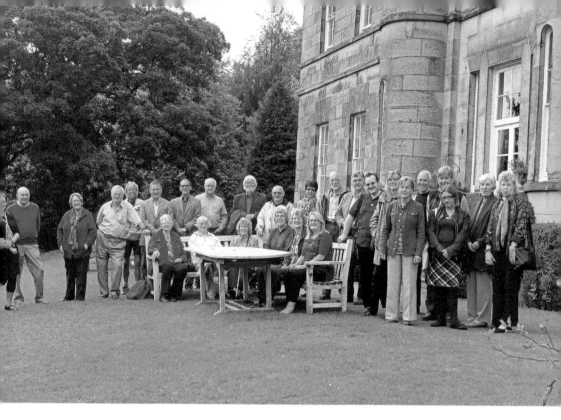

Gathering at Willersley Castle

Here are just a few of the many people who volunteer and work in the World Heritage Site, gathered outside Willersley Castle, before a training session to help them learn more about the building so they can pass that knowledge on to visitors. The earlier view (*below*) was taken in 1933, five years after the Methodist Guild opened it as a holiday centre, bringing in large numbers of young Methodists to enjoy the facilities, including tea on the front lawn.

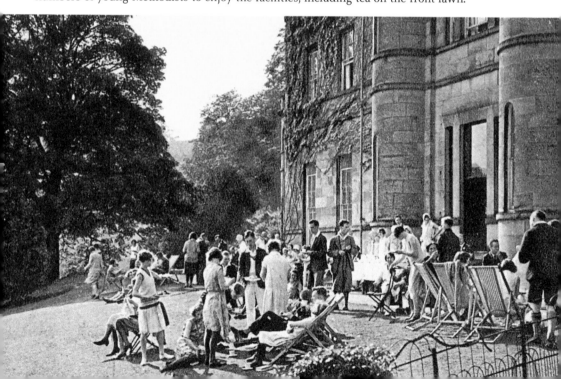

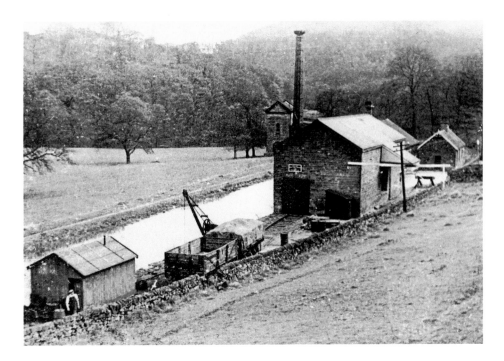

Warehouse on the Cromford Canal

Moving south, Cromford Canal towpath leads you to High Peak Junction and this warehouse, with the wharf behind. Before 1967, this linked the canal to the Cromford and High Peak Railway, and you can see trucks and rails in the older image. The paddock in the foreground had become a mass of trees in recent years, but it has now been cleared, restoring the view. The Leawood Pumphouse, with its tall chimney, is just behind the warehouse. The towpath is now a popular walking route. The warehouse door sign is unchanged, warning engines and not to enter.

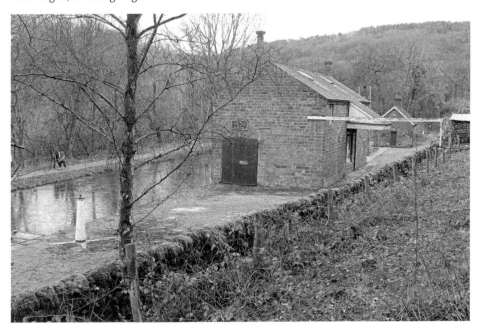

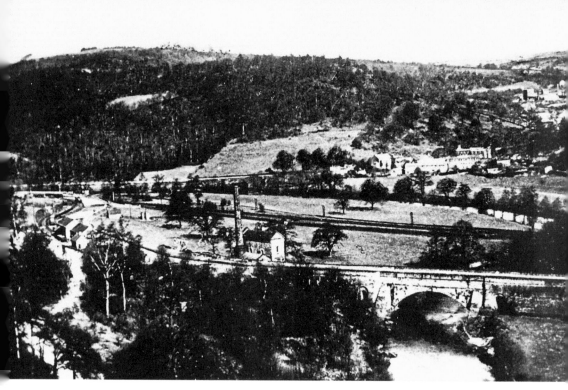

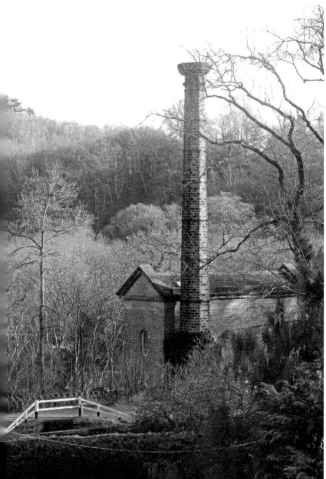

Leawood Pumphouse from the West

This view of the landscape around Leawood Pumphouse shows off the World Heritage Site's rural setting well, and includes the canal crossing over the river via the Wigwell (or Derwent) Aqueduct, and Lea Bridge, home of the John Smedley mills, beyond. The valley is more wooded now, and glimpses of the pumphouse from the west are rare, but you can spot the chimney from the A6 road – just. Leawood Pumphouse was built in 1849 to increase the water supply to the canal by pumping huge quantities up from the river when needed. You can still see the Boulton and Watt beam engine in action on occasional weekends through the year.

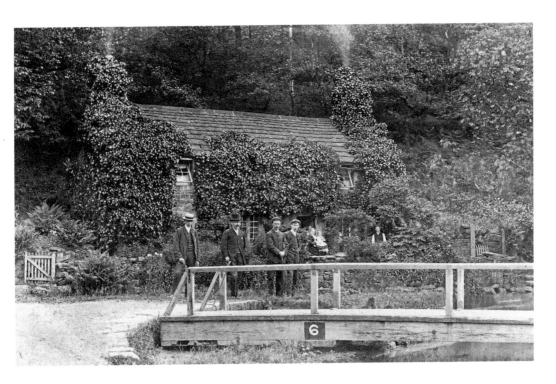

Aqueduct Cottage

The cottage standing just south of the Wigwell Aqueduct is now in a sorry state. Originally two dwellings, it stood at the junction with Peter Nightingale's private arm of the canal, leading to Lea Bridge. The postcard view above, posted in 1909, sees the cottage in use, although it never had a water or power supply. Today, it is a ruin, but the new owners, the Derbyshire Wildlife Trust, are looking at options for its future. The swing-bridge in the foreground is still widely used by walkers following the towpath.

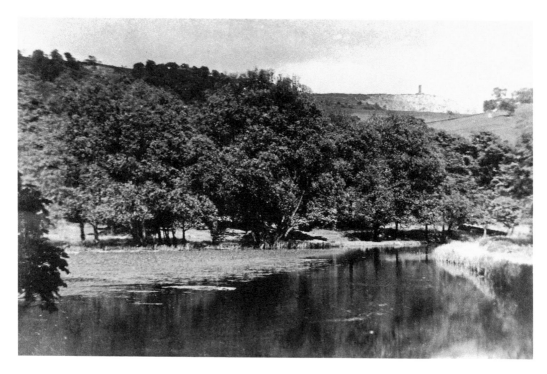

Crich Stand from Gregory's Tunnel

Continuing southwards along the canal, this is the view as you leave Gregory's Tunnel. The pool in the foreground was known as Gregory Wide Hole, but is much reduced in size today thanks to encroaching vegetation growing on many years of silt. In the distance is Crich Stand, the memorial tower for the Sherwood Foresters, built in 1923. The older view shows its predecessor – a gritstone viewpoint tower unveiled in 1851, replacing an earlier structure.

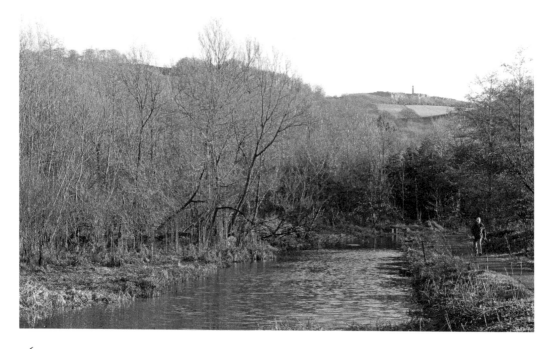

Robin Hood

Robin Hood is a picturesque hamlet nestled by the side of the Cromford Canal, just north of Whatstandwell. Once, this was a wharf for loading quarried stone. Tree growth along the canal denies us a modern view of the whole settlement, but it does mean you come upon this pretty spot more suddenly as you walk south along the towpath.

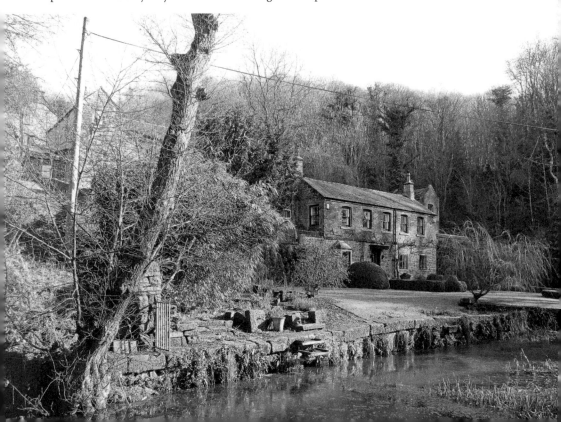

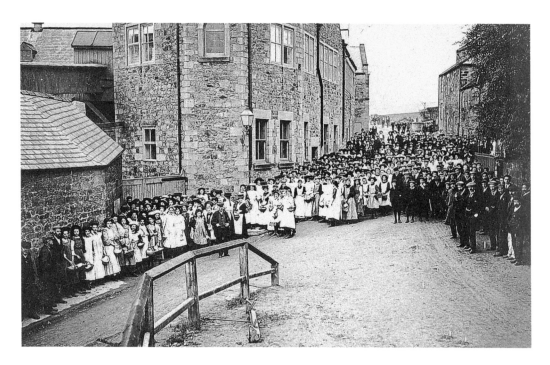

John Smedley's Lea Mills

Textile production at the John Smedley site in Lea Bridge has been constant since the eighteenth century. In the older view, the roof of the original mill can just be seen at the top left, but is now hidden as the mills expanded in the early twentieth century (and a bridge across the road introduced). Above is just half the workforce, shortly before the First World War, photographed during their dinner break. Below are the John Smedley archivists, who are now cataloguing, researching and conserving the company's historic collections.

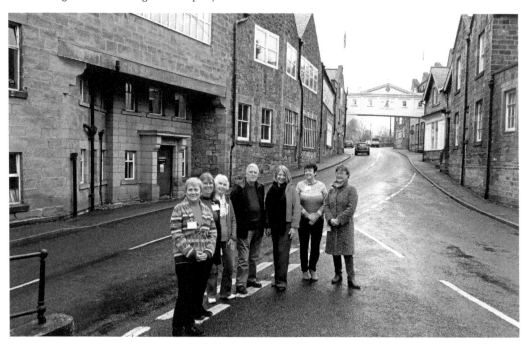

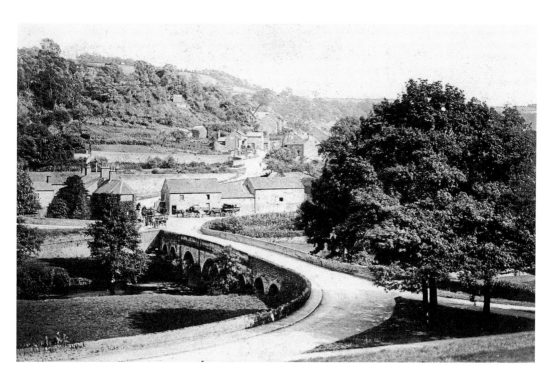

Whatstandwell Bridge

This bridge is a key crossing point across the Derwent, taking the busy A6 road. In the earlier view you can see the village of Crich Carr, now better known as Whatstandwell, the name originally given only to the bridge and buildings in the foreground. The name is supposedly a corruption of Walter Stonewell who rented a cottage near the crossing when a bridge was built here in 1391. Again, the increase in woodland makes it harder to appreciate the view today.

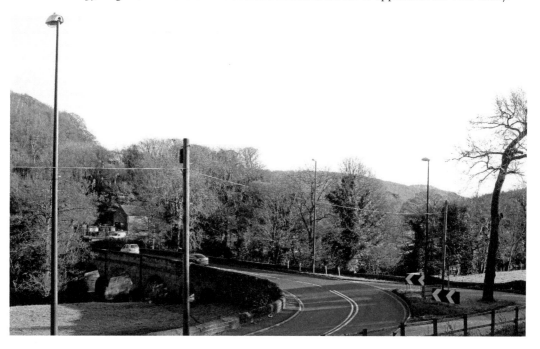

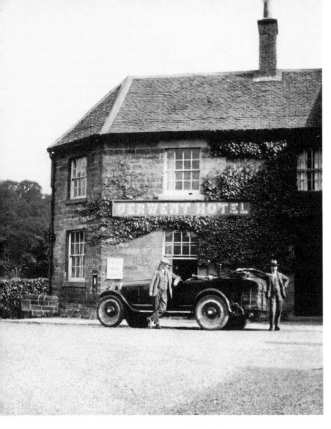

Derwent Hotel to Family Tree
The Derwent Hotel was ideally placed by Whatstandwell Bridge to attract passing motorists, as can be seen in this photograph from the 1920s. On the first Ordnance Survey map of 1880, the building is recorded as the Bull's Head Inn. After a period of closure, it reopened in February 2014, and as can be seen below, the building changed its name again. It is now a coffee lounge and restaurant – The Family Tree.

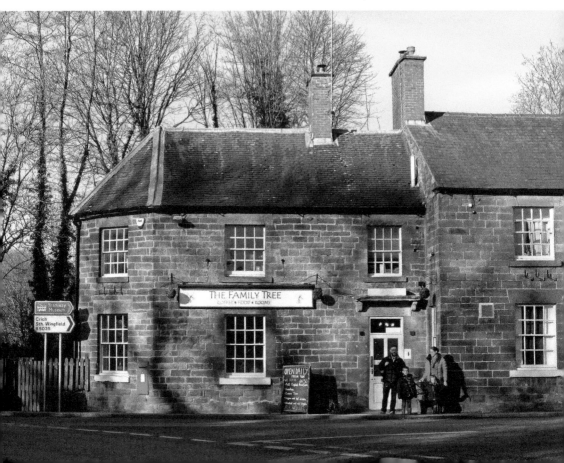

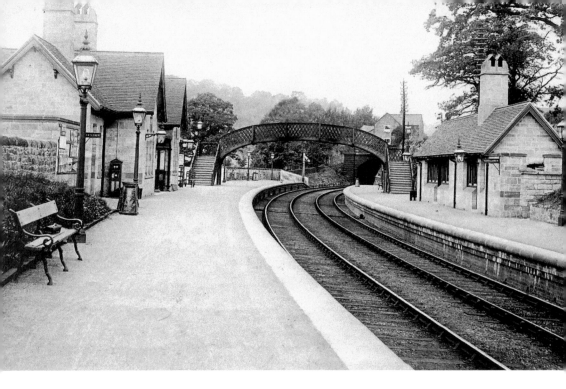

Whatstandwell Station

There has been a railway running through this section of the valley, north of Ambergate, since 1849. The original station, more correctly known as Whatstandwell Bridge, was on the other (northern) side of the tunnel you can see in the distance. This later station opened in 1894, with waiting rooms on both platforms and a ticket office incorporated on the west side. Now, the line is single track, the eastern platform is closed and abandoned, and the buildings long gone. The footbridge, however, has been repainted in appropriate colours for what was once a Midland Railway station.

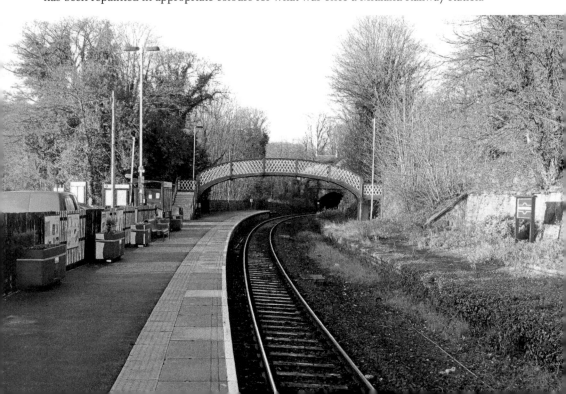

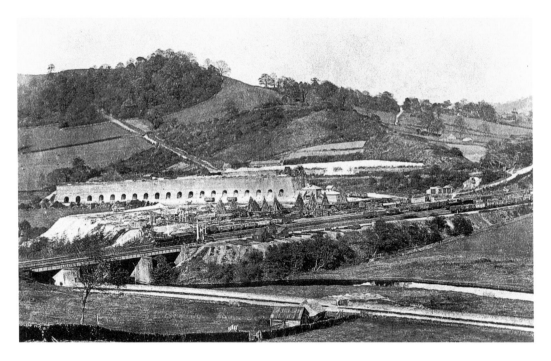

Ambergate Lime Works

George Stephenson's lime works were created at the time he and his son built the North Midland Railway through Ambergate in 1838–40, using limestone and coal deposits discovered during the construction of the railway. They were demolished in 1966 to create a gas processing and storage centre. The wooded valley makes it difficult to view the site today, but you can catch a glimpse from the train window (*below*). Inset is the gas works in April 1968, as it was being modernised to accommodate natural gas.

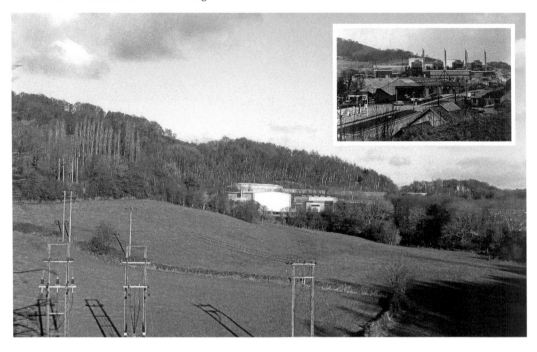

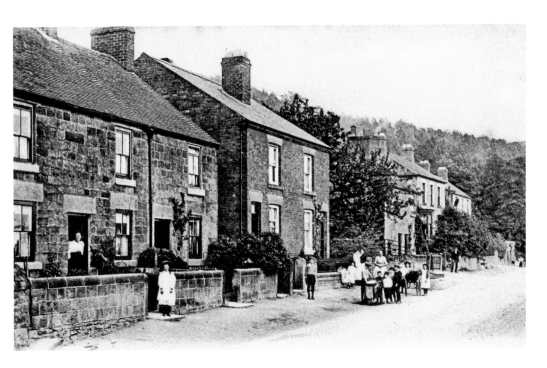

Expanding Ambergate

Ambergate village was originally the hamlet of Toadmoor (a corruption of 't'old moor', in the local dialect), until the turnpike road, with its gate by the River Amber (*inset, c. 1880*), opened in the early nineteenth century and the new name took hold. This view looking south along that turnpike road (now the A6) shows how the village has continued to grow – these cottages once formed the southern boundary of the village, but many more have been added during the past century.

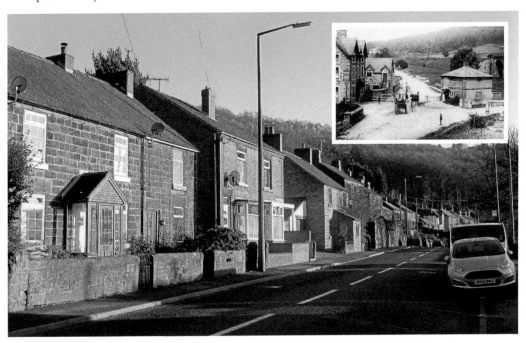

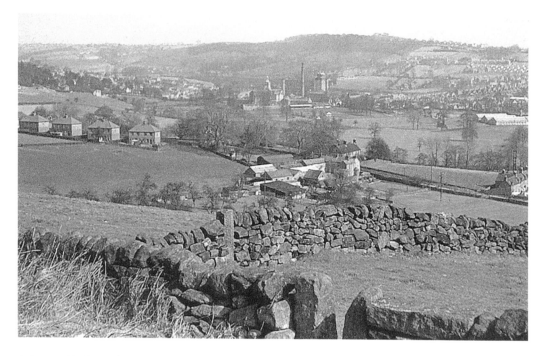

Belper Mills from the Chevin

The vast mill complex at Belper draws the eye when looking from the Chevin Hill in the west. This is a favourite view of mine, showing the mills in their wider valley setting. The earlier photograph is from before the demolitions, which began in 1959, with the West Mill, Jubilee Clock Tower and chimney still clearly in place. The later view shows the changes to Chevin Green Farm (in the foreground), which now provides holiday accommodation.

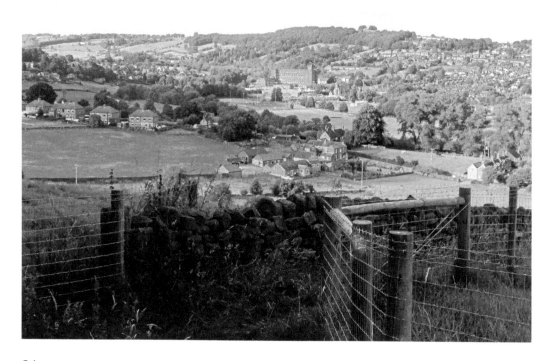

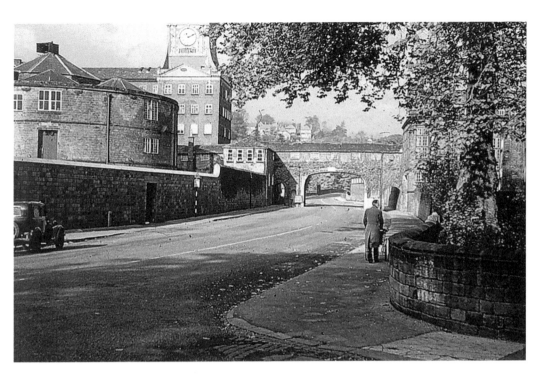

The Round Mill and Jubilee Clock Tower at Belper

William Strutt's unique Round Mill of 1803–13 can be seen above, before its demolition in 1959. Four men died when it suddenly collapsed during the work. The clock tower behind, finished in 1898 to belatedly commemorate Queen Victoria's Diamond Jubilee, is better seen below, in the short period between 1959 and the tower's own demolition, with the West Mill, in 1962. Inset, the present-day view is rather less commanding, although the 1795 gangway, a footbridge linking the mills, still stands, despite several collisions with tall vehicles.

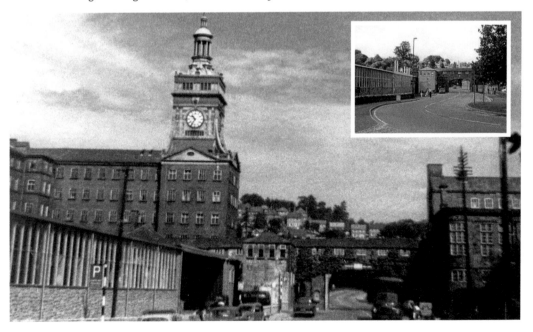

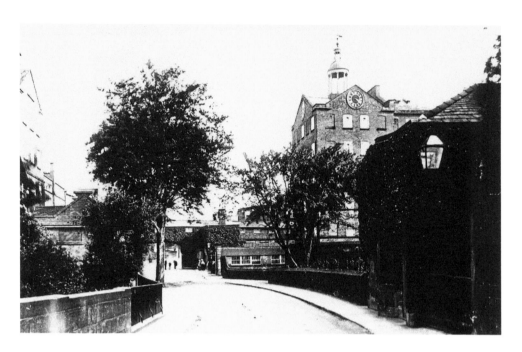

The West Mill at Belper

You can see the gangway again in this view, looking from the other side. On the right is the original West Mill of 1796, shortly before the Jubilee clock tower was added. The eight-pillared cupola seen on the roof was reused to top the clock tower in 1898. Tower and mill were demolished in 1962 and a modern, single-storey factory built, which retains the old 'West Mill' title. It is still in use today, as the only hosiery producing factory in the East Midlands.

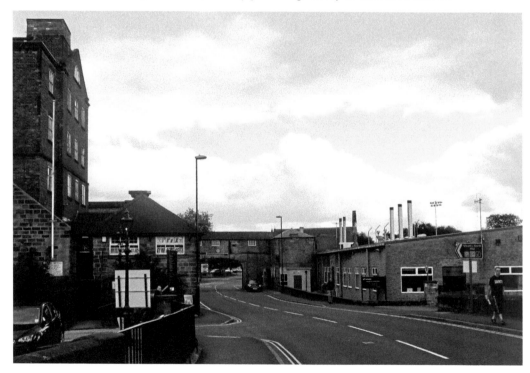

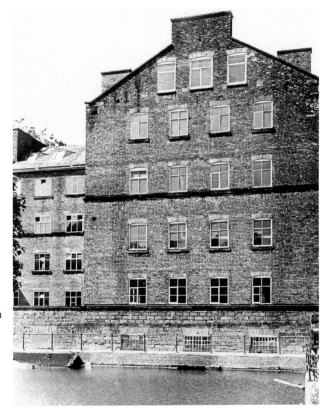

The South Mill and Sluices

Jedediah (sometimes spelt Jedidiah) Strutt built his first mill at Belper in 1776. His son William rebuilt it in 1812 to fireproof the building. It became known as the South Mill, and can be seen in the top photograph, before demolition in 1962. The ground floor wheel pit was converted to water turbines early in the twentieth century. They and the section of mill in which they sat were preserved, as a flat-roofed turbine block, surviving the other clearances of the 1960s. The turbines have been modernised since then, and the production of power from the site continues today, through Derwent Hydroelectric Power Ltd, who lease the site. The present-day view shows the empty stone-lined water channel during repair work on the turbines. The bottom right-hand window on the older image is the same right-hand window you can see in the present-day photograph. The modern West Mill can be seen behind.

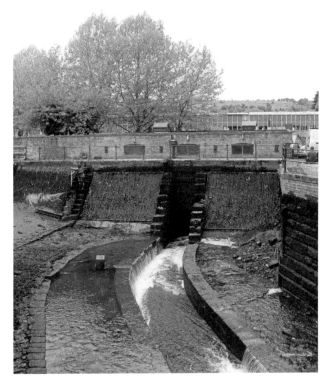

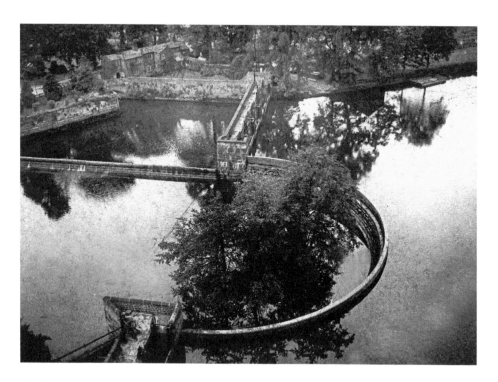

The Horseshoe Weir

Belper's Horseshoe Weir was constructed in 1797, when the creation of the West Mill required a greater head of water to power the additional waterwheels. It replaced an earlier weir further upstream. The earlier view is from the top floor of the North Mill c. 1912. That year, the East Mill was built, and it is from this later mill that the modern-day photograph is taken. The trees in the weir basin appear in the earliest illustrations of the weir and may have been on the riverbank before the weir was built.

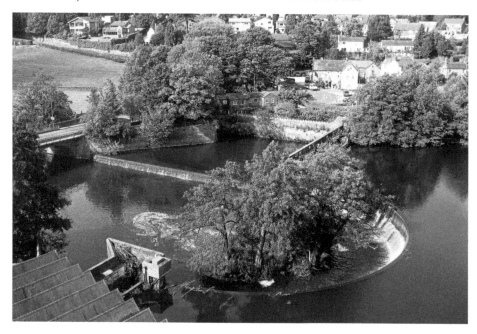

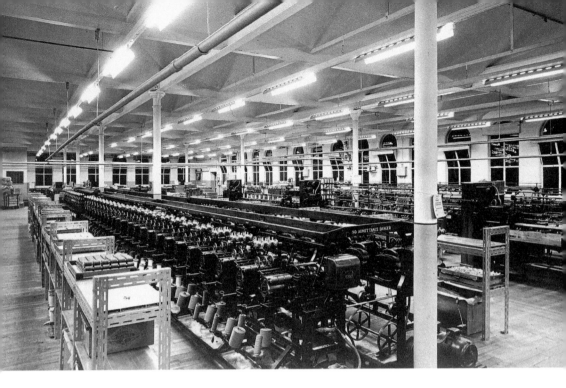

Inside the East Mill

Belper's East Mill of 1912 is the largest in the valley. Since closure in 1987, the top floors have barely been used, except for storage, so remain empty and unchanged. Interior views are rare, but above is the top (seventh) floor in 1953, after strip lighting was introduced. Below is the fifth floor on a rare public opening for 2010's World Heritage Site Discovery Days Festival. The peeling paint on the ceiling is a sad sight – a new, appropriate use is needed for the mill, as has happened at Masson, Darley Abbey and Cromford.

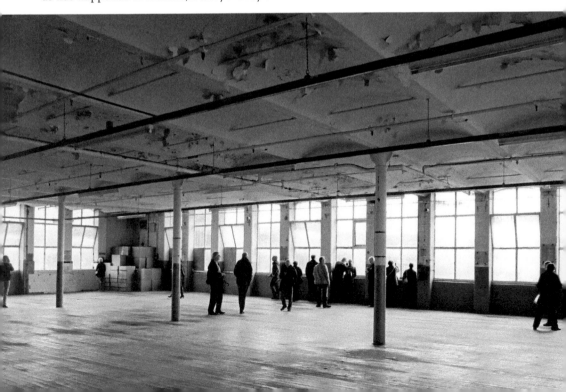

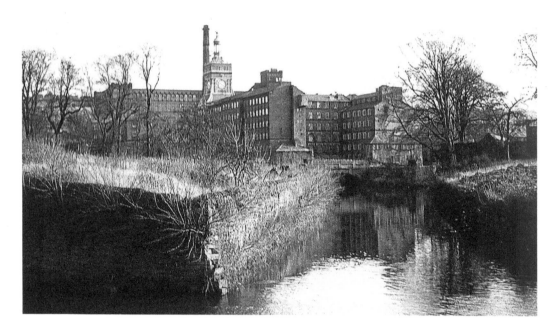

Returning to the Derwent

Here, the water from the mill leat returns to the Derwent, south of Belper's mill complex. The mills, including the clock tower and chimney, could be seen easily in this early colour photograph from the 1950s. Today, several built landmarks have gone, and those that survive are well hidden by vegetation. Plant growth isn't just a problem for views – the West Mill car park wall is being undermined (*inset*) as roots grow and spread. How long before part of the car park is in the river?

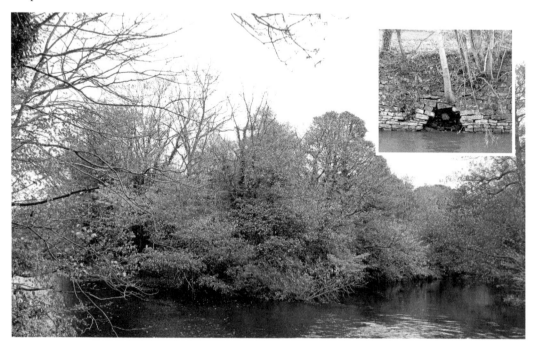

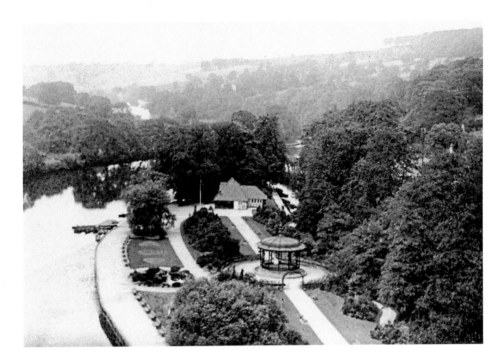

Belper River Gardens from the East Mill

The building of the East Mill provided, for the first time, this view of the River Gardens, taken in 1912 – the year construction was completed. The autumnal view below shows that while some trees have gone, others have matured, and the gardens are as attractive as ever. Hidden from view are the 1906 Swiss Tea Rooms (beyond the bandstand in the older photograph) – they are still there but in a poor state. There are plans to demolish the tea rooms and replace them with a new café building.

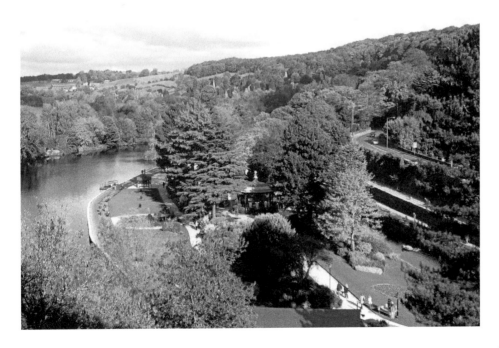

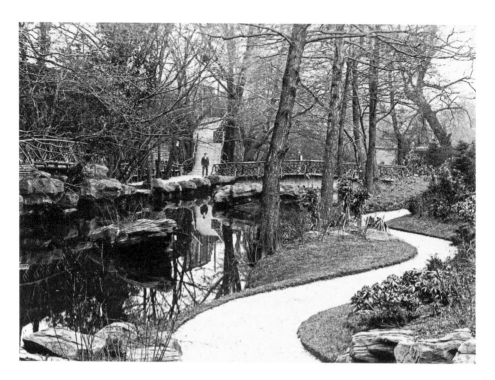

The Serpentine Walk

From 1907, visitors to the River Gardens descended down steps from the Matlock Road entrance, crossing the bridge over the mill leat to reach this Serpentine Walk, which weaved its way through the gardens to the tea rooms, past artificial stone rockeries. Today, the bridge is still there, but the entrance and Serpentine Walk have disappeared. Beyond the bridge, the water has been covered over to provide parking spaces.

Bridgefoot from the River Gardens

Before the Second World War, there was a clear view of Bridgefoot and Wyver Lane from the River Gardens. The three-storey farmhouse stands out. To its left is the Talbot Inn, with smoke coming from a chimney, so old it needed major rebuilding work in 1660. To the right is the tall terrace of millworkers' housing on Wyver Lane, with gardens on the opposite side of the road, leading down to the river. In the foreground is the River Gardens fountain. Even in winter, the view is now almost fully blocked by trees. You can just pick out the windows of the old farmhouse above the fountain. Many houses have been built behind.

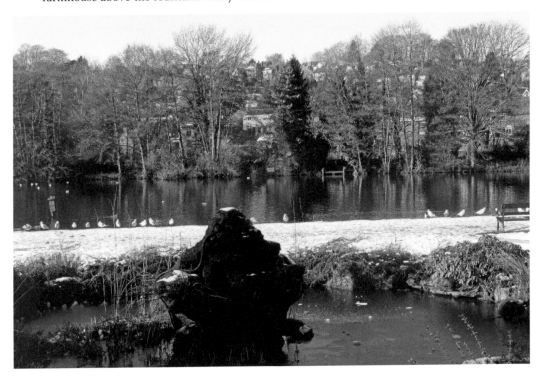

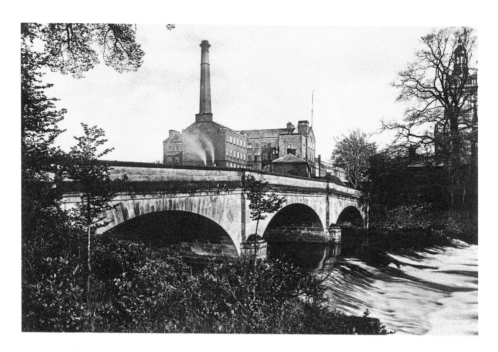

Belper Bridge

The bridge across the Derwent, built in 1796–98, replaced an earlier bridge swept away in 1795. It proved to be too narrow for twentieth-century traffic, and cantilevered pavements were added in 1955/56. The addition of the East Mill in 1912, and loss of the mill chimney in 1990, impact on the view. There's smoke coming from the mill yard cottages in the older photograph – these were demolished in the 1960s. The Rock Weir, downstream from the bridge, can be seen more clearly in the modern photograph, taken during a drought. The collapse, half way across, grows in size each year and needs repairing.

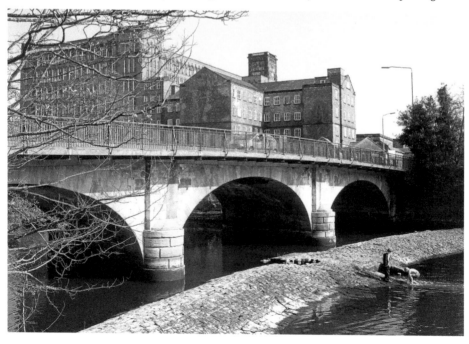

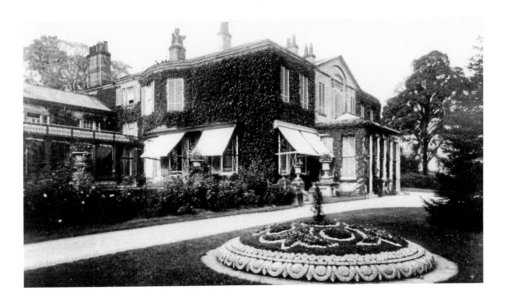

Echoes of Bridge Hill

George Benson Strutt, second son of Jedediah, managed the Belper mills for many years, and built his home, Bridge Hill House, close by. It was completed in 1796. Five generations of Strutts lived there, but in the face of crippling death taxes, and no buyer, they were forced to demolish it in the 1930s. A housing estate was built on the site after the Second World War. Lining up the old and new maps suggests this is almost the same view, taken in the back garden of a house on Lodge Drive, and that the modern circular flowerbed below is in the same position as the circular flower bed in the older image.

The Bridge Hill Gateposts

The gardens of Bridge Hill House were extensive. At the rear were these fine-looking stone gateposts. Together with the contents of the house, they were auctioned off before demolition of the property began. The modern view isn't of the same spot, nor even in Belper, but shows the posts where they stand today, by the roadside on the Ripley Road just outside Heage, looking as impressive as they ever did. They were incorporated into the boundary wall of a farm by their new owner.

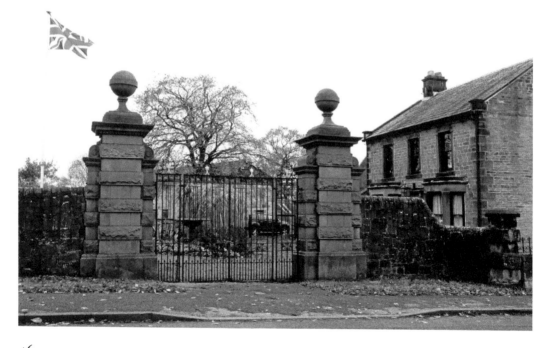

The Triangle

In the days before motor vehicles were so abundant, the Triangle was an open space, and drivers were left to their own devices if heading to Ashbourne (left) or Matlock (right). Buildings were demolished shortly before the First World War, allowing the creation of a triangular space with low wire fence in the centre. Beyond is Bridge House, partly in use as a school by this time (1919), with the mill chimney and East Mill in the background. Today's view highlights the more formal arrangements for traffic, and a CCTV pole has replaced the gas lamp. For such an impressively large building, the East Mill hides well behind the trees!

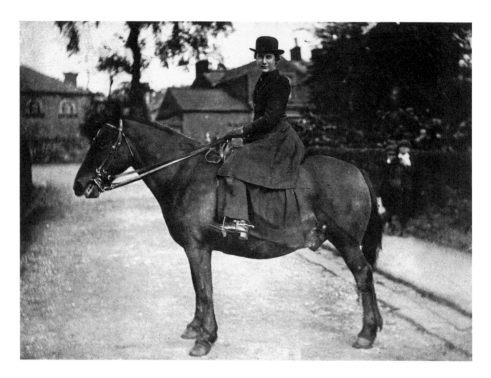

George Street

Much good-quality housing was provided for the Strutt workers in Belper. Some roads were of a superior quality too. In the Clusters area, a Telford-style road, constructed of differing sizes of limestone, used horses' hooves and cart wheels to bind together a solid, attractive surface. The road here, at the top of George Street, is degraded and partly resurfaced since this photograph was taken of an unknown lady on horseback, *c.* 1900. Efforts are being made to restore these historic, privately owned, roads. The Strutt-built Unitarian chapel, with its distinctive arched windows, can be seen clearly in the older image, but is partly obscured in the modern view by a house built for the minister.

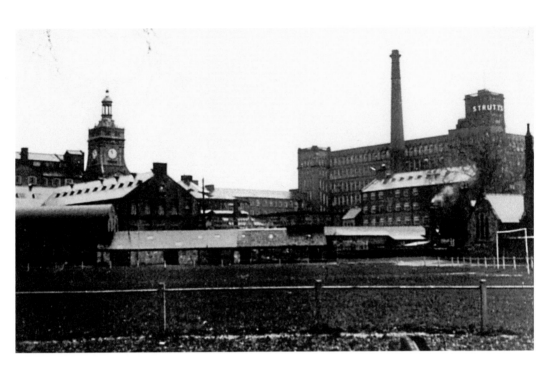

The Mills from Christchurch Meadows

The Meadows by the river have been used for formal sporting activities since the mid-1800s. From 1951, Belper Town Football Club began playing here as well. The mill complex can be clearly seen beyond. In the older image, the 1959 demolition of the Round Mill has taken place, but the clock tower (*left*) and South Mill (*in front of the chimney*) still stand, so it's not yet 1962. There are fewer mills to see in the later view, but the red bricks of the East Mill are striking against a blue sky and green pitch.

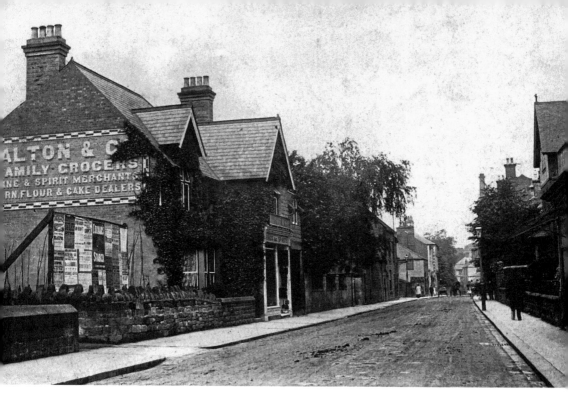

Bridge Street

Bridge Street is rarely traffic free these days, being part of the busy A6. The billboard in the older view advertises excursions to Manchester, Liverpool, Blackpool and Buxton, as well as mundane household items like starch. It was eventually replaced by a shop – now Lloyds Pharmacy. The building next door was for much of the twentieth century Alton's – a grocer providing high-quality and unusual fancy goods, such as crystallised ginger.

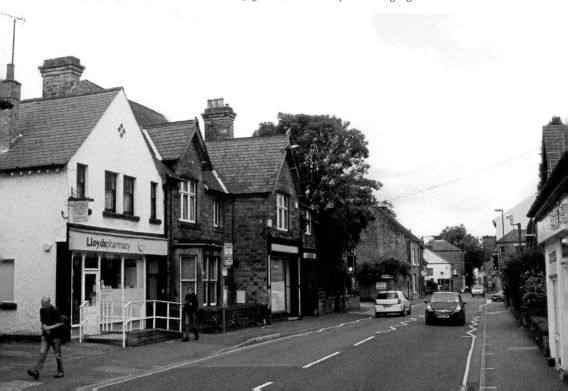

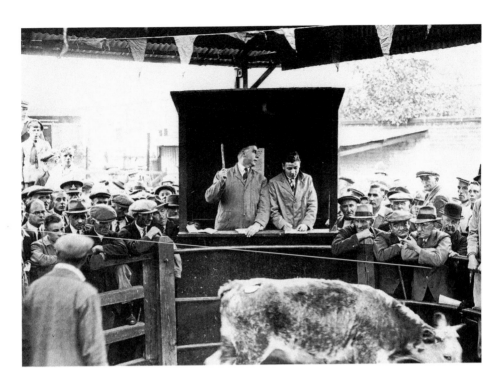

The Cattle Market

Belper's Smithfield Cattle Market operated from 1904 until 1965, in what is now the Field Lane car park. Beyond this busy scene, at a wartime auction to raise money for the Red Cross in June 1943, you can just see the terrace of houses on Wellington Court, which stand at the edge of the car park today.

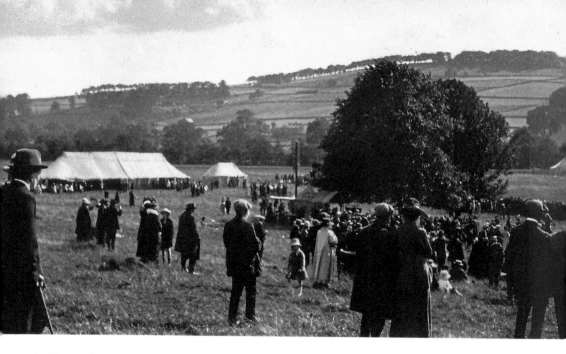

Salt's Meadow

The fields by the River Derwent have been well used for many years. Salt's Meadow, better known in later years as Thornton's Field, lies at the western end of Derwent Street, and has seen all types of events, from circuses in the nineteenth century, to the Belper Vintage Event in the latter part of the twentieth. Above, visitors to Belper Horse Show were photographed by Emily Strutt in July 1920. The show had been a popular event on the meadows since 1891, but this was one of the last. Today, car park fencing partly blocks the view, but Sunday footballers still use the field.

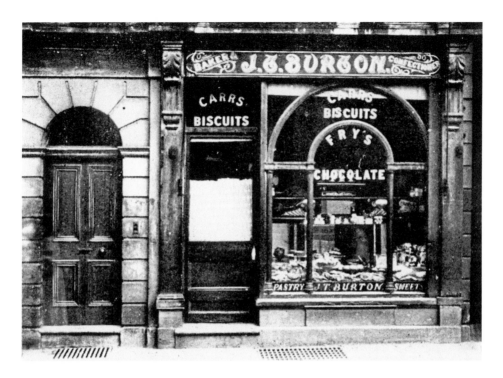

Burton's of Bridge Street

The display in the arched window of Burton the Baker looks a real treat in 1911. The shop was one of four built in 1852/53 with these distinctive windows, but all the arches were lost in the century that followed. The shop is unrecognisable today, and the arched doorway knocked out to make the shop front larger (an identical arched doorway survives two doors up, by Frearson's shop). Thanks to a local grant scheme, the neighbouring shop had its original look restored and is now rather stylish.

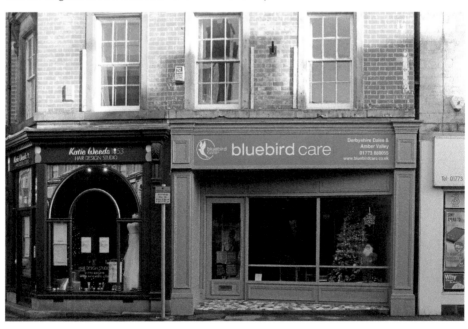

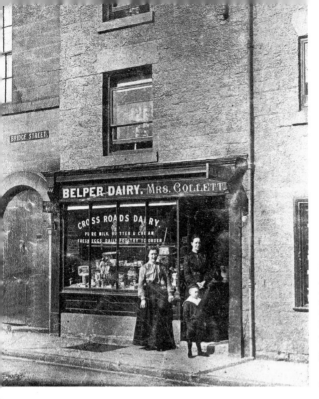

Belper Dairy

Almost opposite the King Street junction, No. 5 Bridge Street was once known as Belper Dairy, run by Mrs Collett, a relation of the Harrison family, who supplied her with dairy goods from Wildersley Farm on the southern edge of town. The shop was empty for some time, and in a poor state, but has now had a new frontage and reopened as Pellegrino. The two sash windows above have long gone, the top one completely bricked in. Next door's attractive archway is hopefully still there, hidden by the neighbouring shop sign. During the 1940s and 1950s, it led through to a dance studio run by Renee Cross.

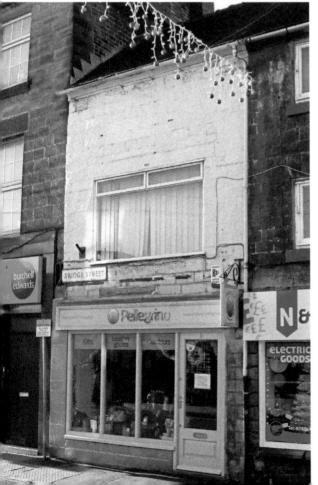

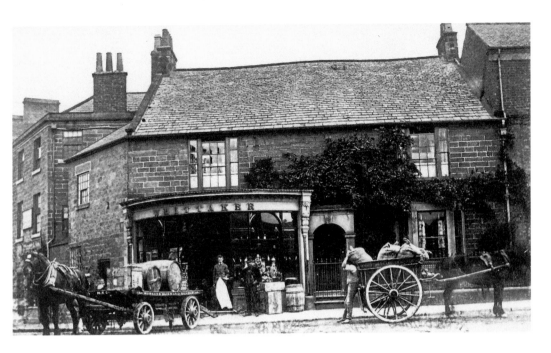

King Street Junction

In the 1880s and 1890s, Whittaker the grocer had a shop on the corner of King Street and Bridge Street in Belper, seen here with two delivery carts outside – the one on the right was his own, the one on the left belonged to the Midland Railway. The shop, with its attractive curved front, was demolished so that the colonnaded London City and Midland Bank (now HSBC) could be built in 1900. It's an impressive building, reflecting Belper's economic strength as a successful industrial town at the end of the nineteenth century.

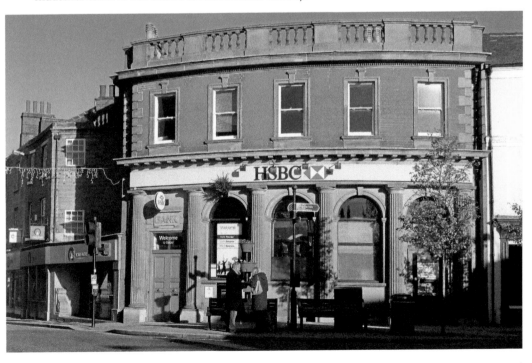

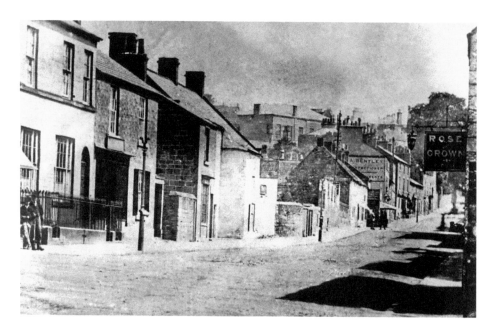

King Street Before the Railway Station

Belper was not only best market town but overall UK winner in the 2014 Great British High Street Competition. The central shopping area is King Street, which has evolved from residential to commercial uses. Comparing the photographs, the two buildings on the left still stand, with shop fronts added. Beyond, the Railway Hotel (formerly the Tiger Inn, before the railway) has been completely rebuilt. The older view is earlier than 1878, as there's no opening for the station, built that year on the site of an old malt house. In the background, the large house is Green Hall – a Strutt residence demolished in 1955/56.

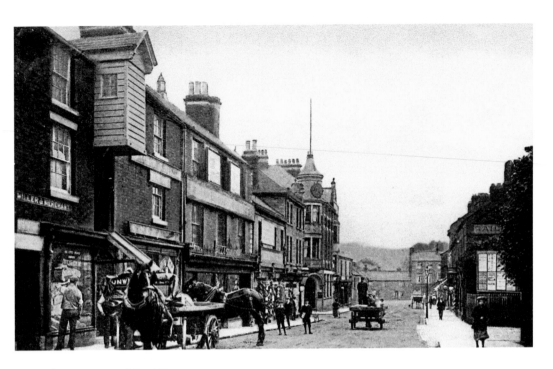

King Street Looking West

The new station had arrived by the time the photograph above was taken, although there are no shops around the entrance (*on the right*) so it dates from before 1914. A supermarket was built across the site in 1973. On the left, the only building to have gone is the corn merchants (with chute above the shop), now a stone-built bank. The clock tower has lost its flagpole. The Derbyshire Building Society closure has left this prominent shop currently empty. It is Ball & Stillman, men's outfitters, in the earlier view.

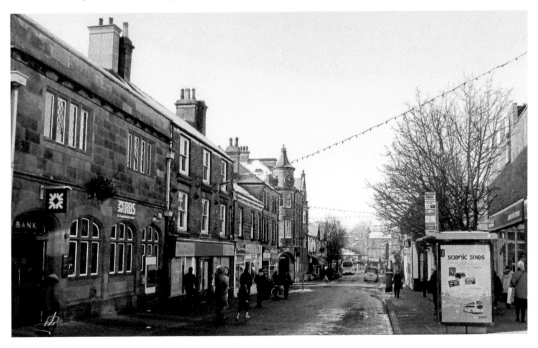

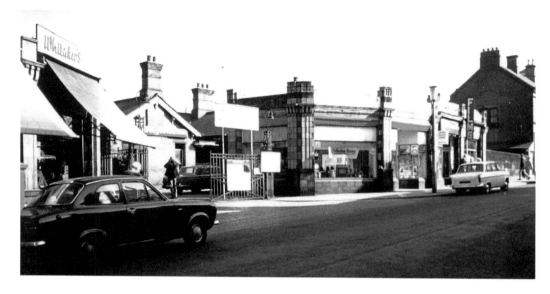

The Railway Station Entrance

The small shops curving in to the station entrance were completed and opened in September 1914. This 1973 view shows them just before the shops on the right, including Rowell's, just beyond the bridge, were all demolished for the building of a Fine Fair supermarket. This has had several owners since then, and now houses Poundland. The ticket office, beyond the iron gates, was also dismantled. The shops on the left, including Whitaker's greengrocery (now Hallmark Cards), survived the changes. The street was partly pedestrianized at the end of the twentieth century, although buses still come through (hence the shelters).

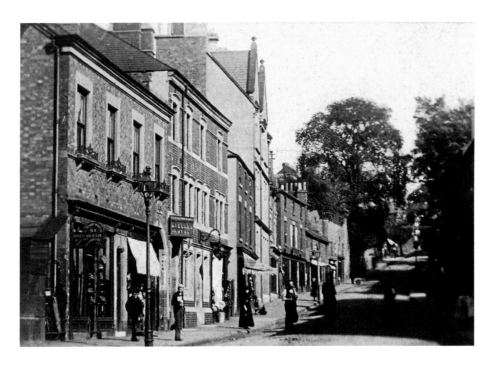

The Midland Hotel and Council Offices

King Street rises as you head east towards the Market Place. Before the rebuilding of 1973, the shops on the left and the Midland Hotel were immediately after the railway bridge. Now, there's no sense of a bridge at all, and the new buildings are rather different. The tall building in the centre was a bank at the time of the first photograph. It was bought by Herbert Strutt and given to the town in October 1918 as a council office in memory of the Belper men who died in the First World War, including his son, Anthony. Spot the 'living statue' in the modern view – a regular visitor on Fridays.

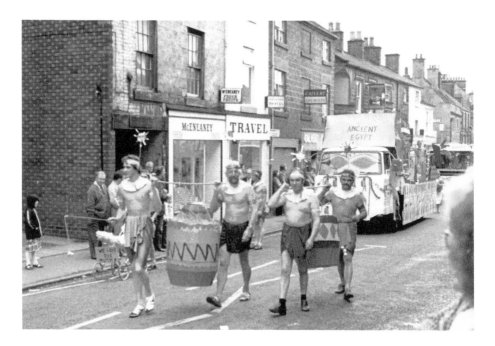

Changing Celebrations

Back in 1980, Belper Carnival was a major part of the town calendar, and the parade passed through King Street. George Street entered a float for several years – that year they were Ancient Egyptians. Belper doesn't have a carnival, or a parade, anymore, but King Street is busier than it's ever been during the food festivals in July and December, with stalls lining the street and thousands of visitors. All the shops seen here have changed hands in the last twenty-five years.

On Parade

Although there are no more carnival parades on King Street, the Remembrance Sunday parades seem to attract larger crowds each year, as can be seen below in 2014. It was rather quieter when this Cub Scout group marched past the same spot on King Street for St George's Day, 1966, although the marching does seem more co-ordinated. The car park to the left, created when Green Hall was demolished in 1956, now has shops facing onto the street.

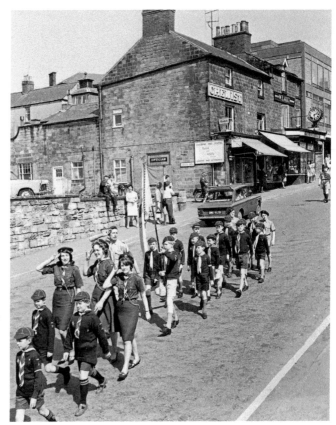

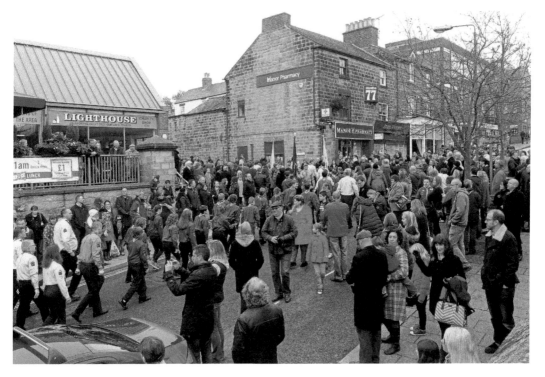

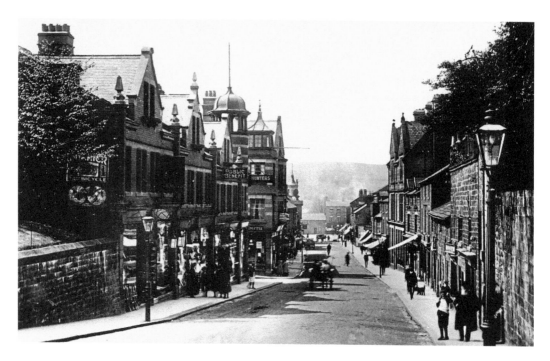

Air-Raid Shelters and the Chevin

This view of King Street highlights the distinctive architecture at roof level – towers, clocks and lantern windows. Carts have been replaced by cars on the street, and sun blinds over shop windows are now a rarity. On the left, the once-solid wall had air-raid shelters inserted in 1939 for Ritz Cinema audiences to go to when the sirens sounded during the Second World War. In the distance is the Chevin hillside, with its ancient ridge route, popular with ramblers.

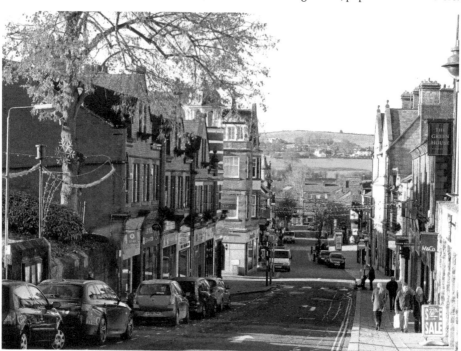

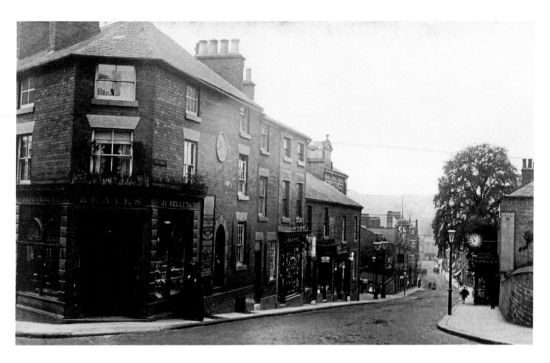

From Watchmaker to Newsagent

Where King Street meets the Market Place, Charles Keates, watchmaker and jeweller, once had his shop, with a clock fitted on the side wall. A rival, John Medley, had his own clock jutting out further down King Street, on the opposite side (now a coffee shop, Fresh Ground). The modern view was taken in October 2014 when present owners Peter and Sarah Athwal celebrated twenty-five years at the shop, now a newsagents and off-licence. They're pictured with assistant Richard Fletcher, who supplied the earlier photograph above.

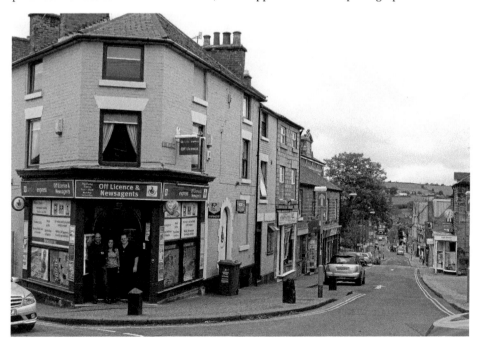

Looking Down High Street

The World Heritage Site is at its widest in Belper, and here we're on the eastern boundary, looking back in towards the Chevin Hill (picked out by snow on the fields in the modern view). On the left is the Grapes Inn, which for several generations was owned by the Hall family, part of Belper's considerable traditional fairground community. Extending towards us from the old corner shop is a new shop, on the right.

High Pavement

In 1911, redevelopment of Belper Market Place led to the demolition of buildings on the southern side of High Pavement. This was a narrow and steep route out of the Market Place, leading to The Butts. The clearing of that side of the channel allowed the creation of a road, which is still in place today (although now a cul-de-sac). The stone setts have long since gone or been covered, and the modern pavement is far wider than the original one, even if you exclude the present-day road. A new terrace, on the far right, was built in 2001, ninety years after the lower end had been cleared.

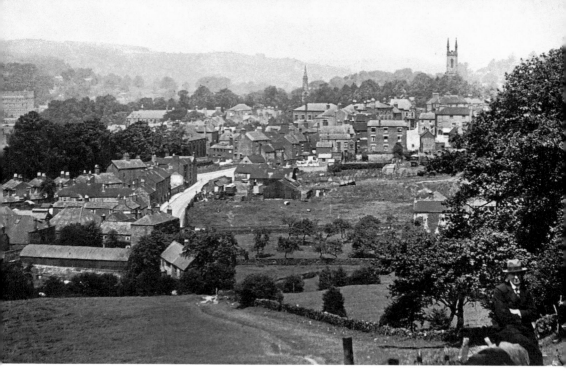

Belper from Byard's Field

Both old and new views of Belper from the south show the impact the East Mill has had on Belper since it was completed in 1912. Other notable landmarks on the horizon are the steeple of the 1874 Congregational church, and the tower of St Peter's church, built in 1822/23 and now sadly missing its pinnacles since a fire in 1949. The original high viewpoint in Byard's Field can't be reached since the building of Raven Oak Close, but it's still worth a climb up the playing field to see across the town.

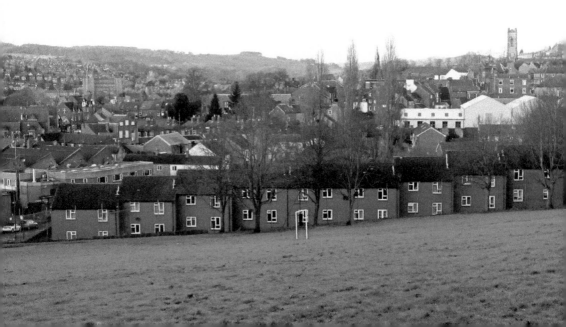

Derby Road

On the south side of the town centre, the A6 road continues towards Derby. Looking back towards Belper, on the right-hand side there were tall trees at the Gibfield Lane junction, effectively hiding the Ward, Sturt & Sharp Hosiery Co. The land was later developed as part of the Dalton's (Silkolene) oil refinery site. In 2004, apartments were built by the roadside. On the right is the boundary wall of the Herbert Strutt School, which lost its iron railings, like so many others, in wartime.

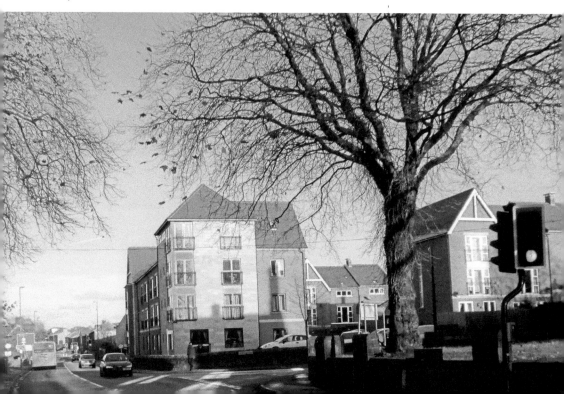

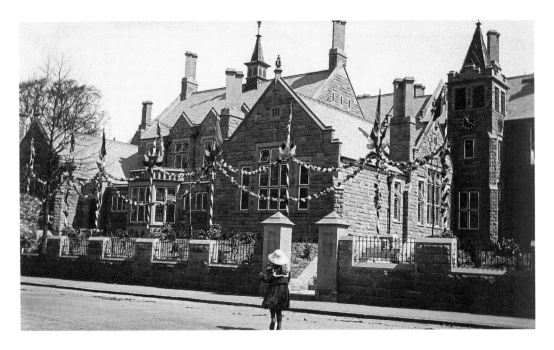

Herbert Strutt School

In 1908, Herbert Strutt paid for a grammar school to be built on Derby Road, costing £20,000. It was given his name. His wife Emily photographed their daughter (either Mary or Charlotte) running to the entrance on the day the school was officially opened by the Duke of Devonshire, in May 1909. There's a barrier to stop children running across the road in these latter days of busy traffic. The buildings are now a community centre, Strutts, run by a dedicated group of volunteers. Inset is Herbert Strutt in 1874, during his own days as a scholar – he was in his second year at Oxford University.

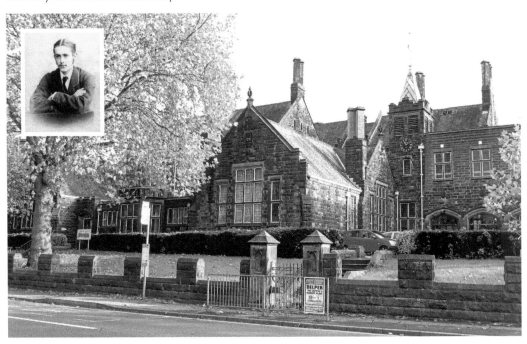

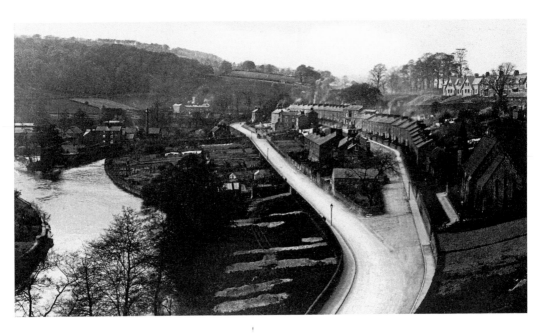

Hopping Hill at Milford

South of Belper is Milford, also shaped by the Strutts. Here, the church and millworkers' housing sit above the A6, with allotments by the river. In the older view, on the far hillside, is Swainsley Court, housing demolished in the late 1950s, partly because there were no utilities. It's impossible to replicate the view today, but the modern photograph highlights the addition of the war memorial, where Hopping Hill meets the A6. Unusually, the roll of honour behind it names all the men of the parish who served in the First World War, not just those killed in action. Housing has been built by the river in recent years.

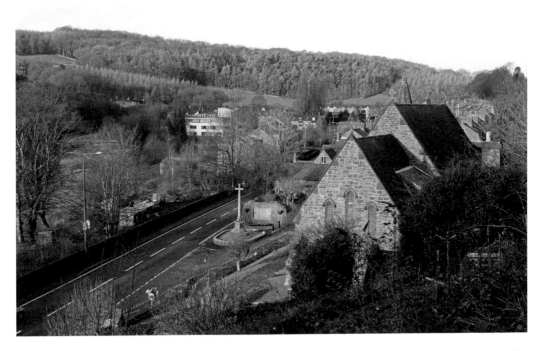

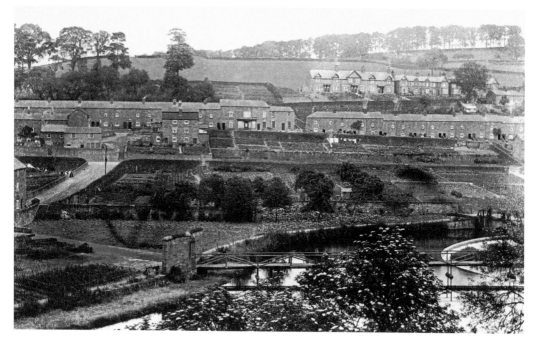

Allotments from Bank Buildings

The Derwent Valley had some of the earliest formal allotments. The Edwardian photograph, taken from Bank (later Banks) Buildings, shows the land between the main road (the A6) and the river was well used. The footbridge in the foreground was swept away in the floods of May 1932. The weir was a natural feature adapted by the Strutts c. 1799. Trees obscure the view from the west bank today, but you can see some of the new housing, and the bright, white cladding on an office block. This once served the foundry that stood on the site for many years.

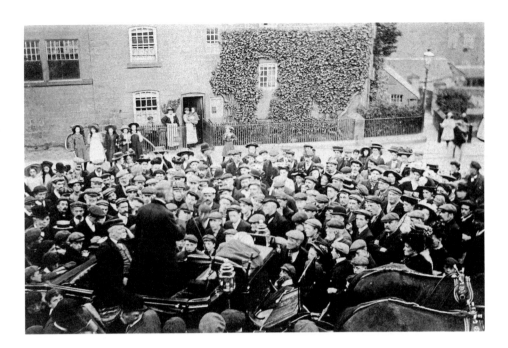

Milford Market Place

Where Sunny Hill meets the Chevin Road, there is a large open space, described in the pre-First World War postcard scene above as 'Milford Market Place'. A speech, probably political, is being given to a considerable crowd. The later photograph shows the Ashbourne U3A Landscape Heritage Group, visiting the valley to find out more about its history, as many groups have since the UNESCO inscription. The windows to the left belong to Milford School – Derbyshire's oldest school buildings still in their original use. The group is standing outside the house once provided for the incumbent schoolmistress.

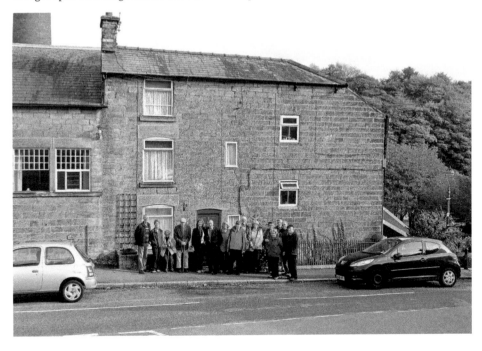

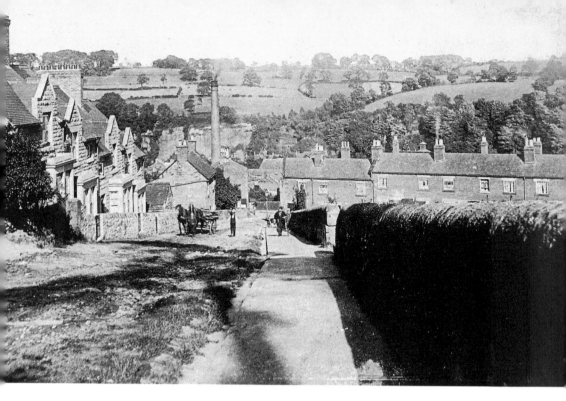

Sunny Hill

The steep incline of Sunny Hill gives good views across the valley at Milford; the mill chimney was still a new addition when the older photograph was taken early in the twentieth century. These days, little can be seen from above of the back-to-back workers' cottages on the right, as new housing blocks the view. From the top of Sunny Hill you can connect with North Lane, which runs across the ridge of the Chevin Hill – a popular route for ramblers.

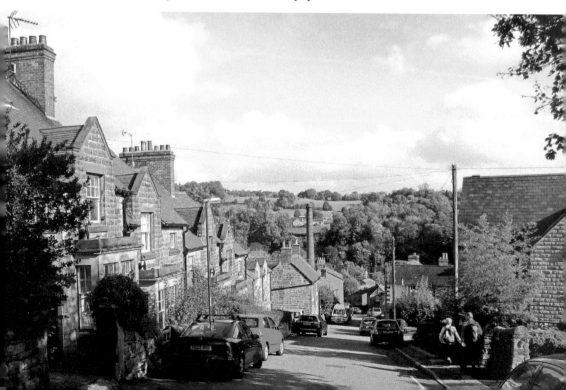

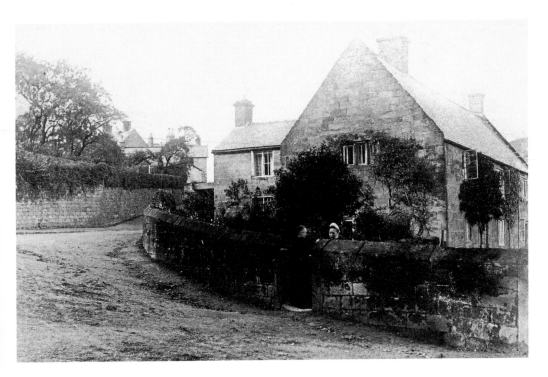

The Old Harvey Farm

This farm, in the centre of Milford, was bought by the Harvey family in 1781, the same year Jedediah Strutt began buying land in the village to create his mills, although they had been tenants before that date. The first Strutt mill in the village was very close to the farm, just to the right of the photograph. From 1781, four generations lived and farmed here, before it was sold to George Herbert Strutt in 1898, and the Strutt Arms Hotel built.

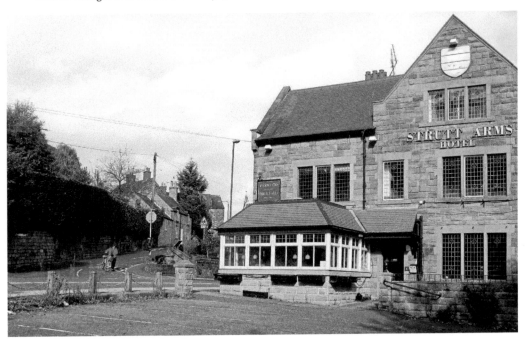

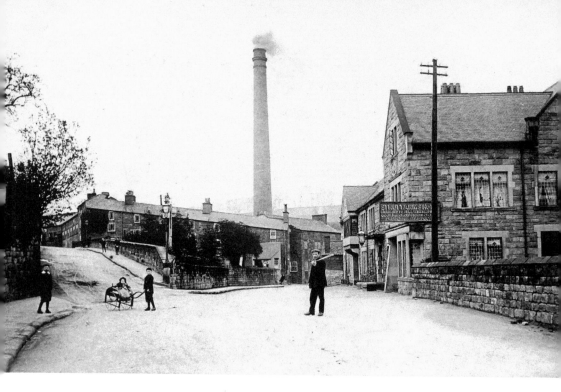

The Strutt Arms

When the Strutt Arms Hotel opened in 1901 it took on the licence of the Beehive Inn, at the bottom of Sunny Hill, which then became reading rooms for the millworkers (and now the village social club). From this angle, you can see the mill chimney and the terraced millworkers' housing. At the junction, there used to be a toll house for people heading onto the Chevin Road (*to the left*), but this had been demolished even before the earlier photograph was taken.

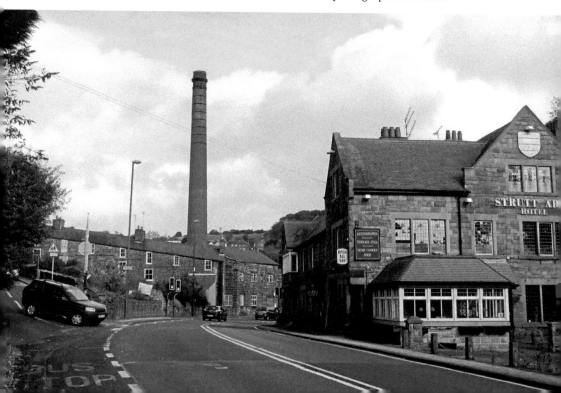

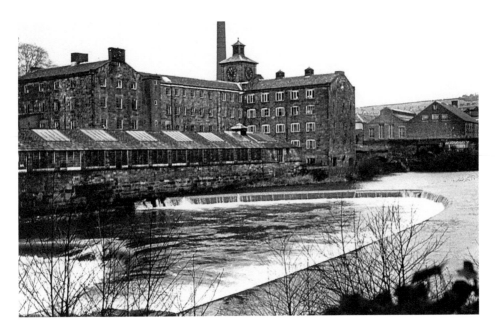

Milford Mills

The Strutt mills at Milford were extensive – and incorporated some notable construction innovations, including three phases of fireproofing. They would have been an important part of the World Heritage Site had they survived. The owners, English Sewing Ltd, demolished the main mill in 1964. *Derbyshire Life* magazine claimed at the time 'it has served a useful purpose but has no place in the modern scheme of things. No tears will be shed over its departure; its preservation is of no importance.' How wrong they were. Today the Mill House pub and grounds cover the site. The single-storey mechanics' workshops by the water have become a terrace on which to sit and enjoy views of the weir.

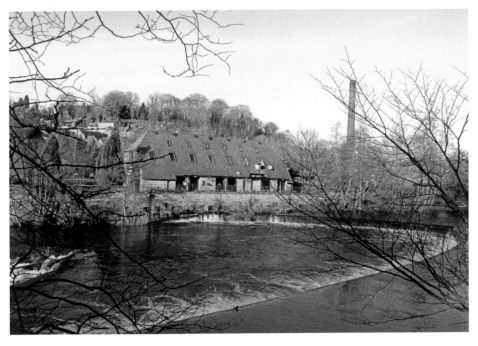

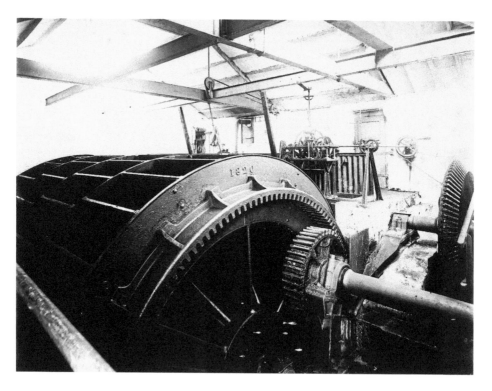

Water Power in Milford

Milford's impressive 1829 waterwheel was photographed just before decommissioning in 1908. It was replaced by more efficient turbines, officially switched on by Mrs Emily Strutt, wife of Herbert, in July that year. When the mill site was cleared in 1964, the 1936 turbine house, holding the generator, was the only building to survive. It is still there today, close to the Mill House pub, providing power for the National Grid.

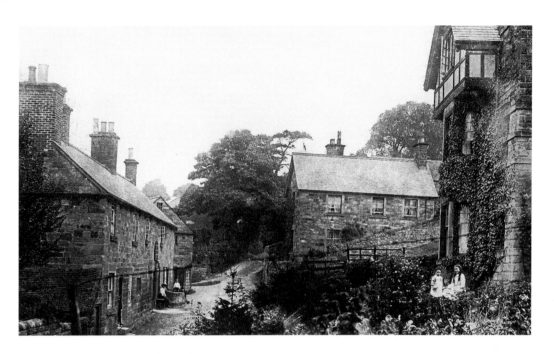

Makeney and the Holly Bush

Just outside Milford is Makeney, home to the Holly Bush (*on the left*). It is an old hostelry, the present building dating back to the seventeenth or early eighteenth century. The building beyond it on the older photograph was the brewhouse, now demolished with a car park on the site. The pub itself has expanded into the neighbouring cottage (*on the near side*). The photograph was taken shortly after the house on the right was built in 1897 for the head groom at nearby Makeney Hall. New housing can be seen in the distance today.

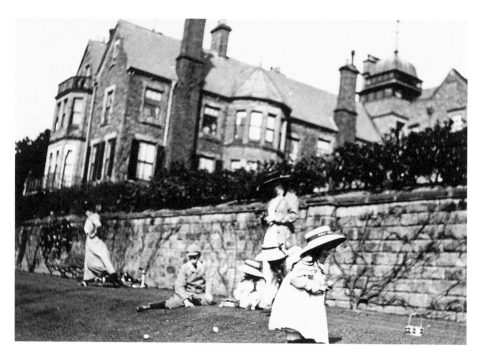

Easter Sunday at Makeney Hall

Herbert Strutt's wife Emily photographed their three daughters, Emily, Mary and Charlotte, looking for eggs on Easter Sunday 1909, in the grounds of their home, Makeney Hall. Sitting on the grass watching the girls is their half-brother Anthony, youngest child of his father's first marriage. Today the house is a hotel. Saplings have been planted by this retaining wall, so the view may soon be lost. Inset is Herbert's great-uncle Anthony Radford Strutt (aged seventy-eight in 1869), who completely rebuilt the original farmhouse on the site *c.* 1820, before making it his home.

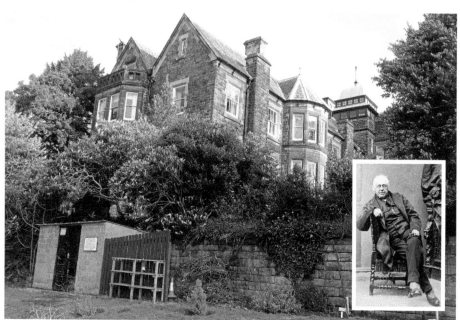

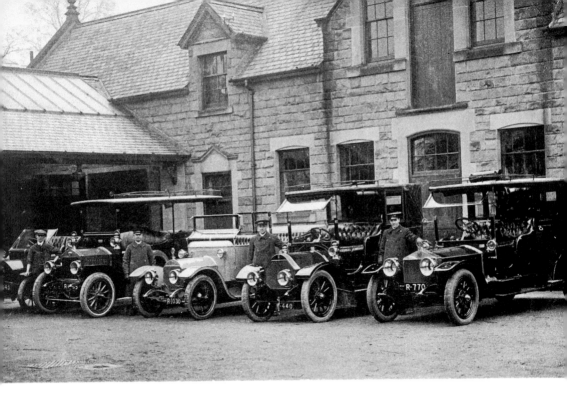

Stables to Garages to Housing

Herbert Strutt was a keen motorist, buying himself a Rolls-Royce Silver Ghost among others. The stables, on the opposite side of Makeney Road to the main house, were converted into garages. In recent years they have been carefully repaired and converted to residential use.

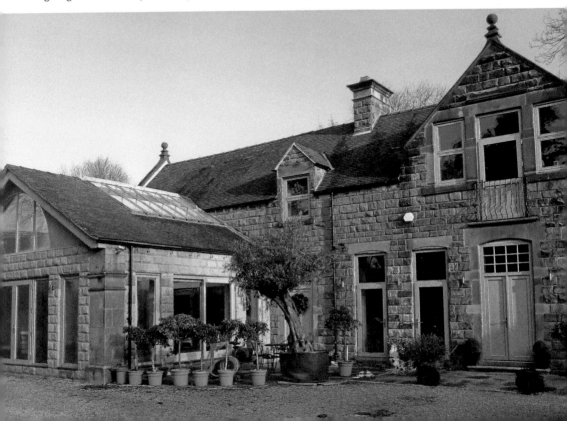

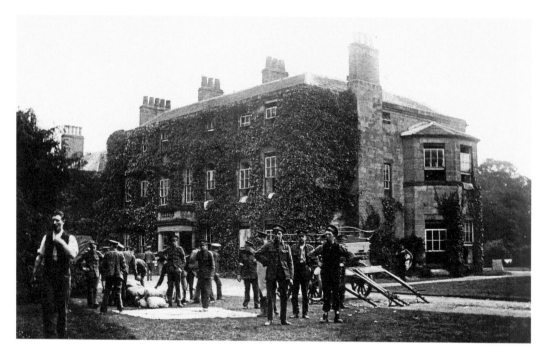

Duffield in the First World War

Continuing south, we come to Duffield. No textile mills were built here, but this historic village once had its own castle. From 12 August 1914, the 5th Battalion Leicestershire Regiment were billeted in Duffield for three days. Some stayed here at Duffield Park. The man in the centre, hand on hip, is believed to be Pte James Edward Atter, who enlisted at Melton Mowbray on 5 August that year, and went to France with the battalion in February 1915. He was killed by 'a rifle shot fired at random' on 16 April 1916, aged nineteen. Today the house has been converted into apartments.

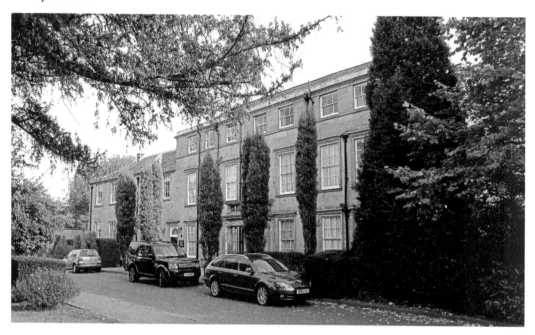

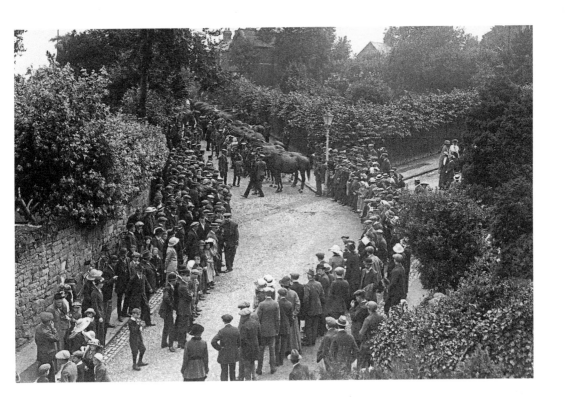

Horses Go to War

Elsewhere in the village, this quiet junction on Castle Hill had seen a large crowd gather on 7 August 1914, to watch Duffield's horses being rounded up for compulsory purchase by the army. They were then taken down to the railway station and herded onto wagons for the first stage of their journey to the Front. These were just a few of the 591,000 horses shipped out of Britain for war work in the early stages of the conflict. Few came back. Today, Castle Hill is a quiet little road once more.

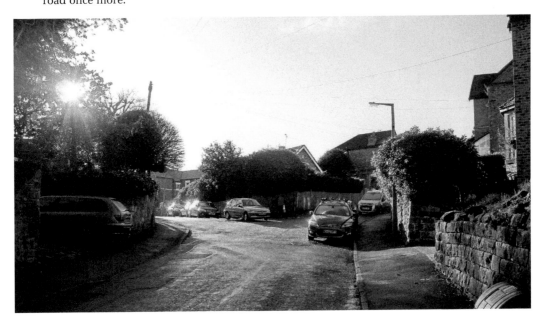

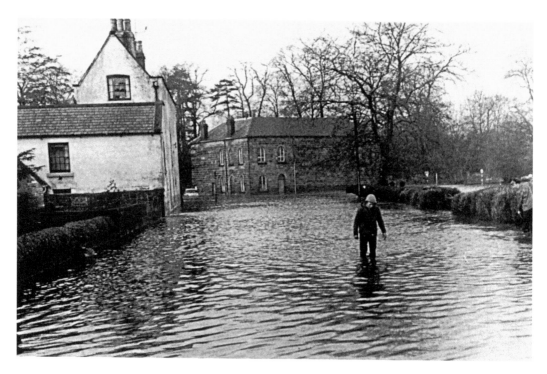

Flooding in the Valley

The River Derwent acts as a major outlet for the rainwater that falls on the Peak District. For centuries, floods have swept away numerous bridges along the valley, and continue to be an issue for those conserving and protecting the mills. The worst floods of the twentieth century were in 1932 and 1965. The scene above is from the latter, when much of the centre of Duffield was submerged. In the background is the 1830 Duffield Baptist chapel, photographed from Makeney Road. Today, the chapel is partly hidden by trees.

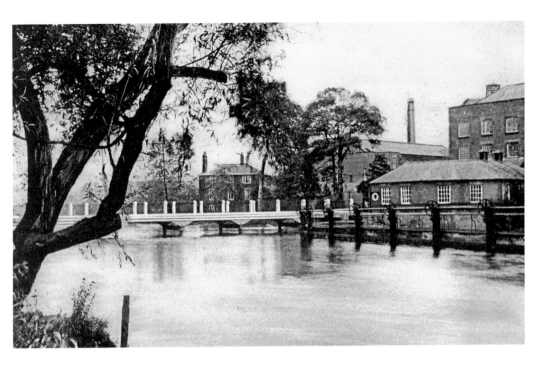

Darley Abbey Mills

Before the Derwent reaches Derby, it passes through Darley Abbey, curling around the mill complex, which the Evans family began building from 1781. The mills connect to the village via a bridge over the river. The old manager's house can be seen beyond the bridge in the older view, but is now hidden by trees. The chimney on the north side of the site has long since gone. The sluices and associated gearing over the weir have been removed, changing the height of the river, and allowing canoeists easier passage. They sometimes attract quite a crowd.

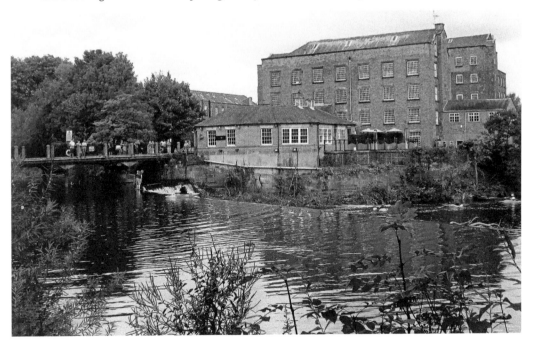

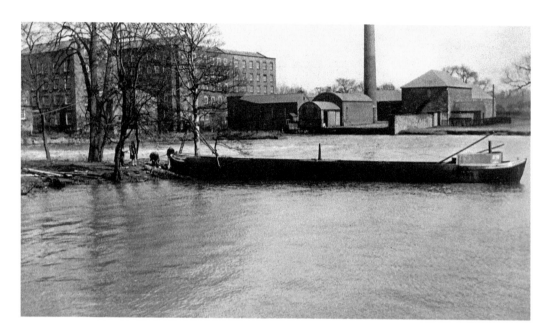

Barge on the River

Darley Abbey weir was once the furthest navigable point upstream for boats. They accessed the Derwent via a canal by St Mary's Bridge at Derby, long-since filled in. There was, at one time, a quay close to the mills. This barge is considerably larger than the canoes seen on the river today. The possibility of a passenger boat service between Darley Abbey and Derby has been explored in recent years; it would be quite an attraction for visitors. Beyond the barge are the West, Long, Middle and East Mills. An island has formed in the river over the past century, populated by trees, which limits the view of the chimney.

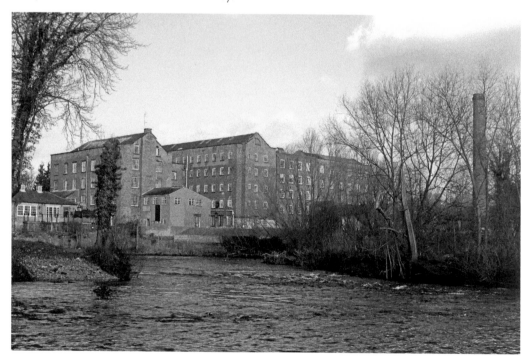

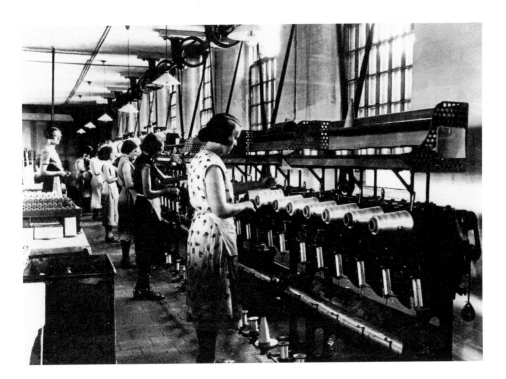

Working in the North Mill

Although water powered the machinery, there was still intensive work for employees in the textile mills. In Darley Abbey's North Mill after the Second World War, these women are operating spooling machines, closely watched by an overseer. Today, the mill has been sympathetically restored and modernised, and continues to provide business space and employment; the same area houses a graphic design company – Fluid.

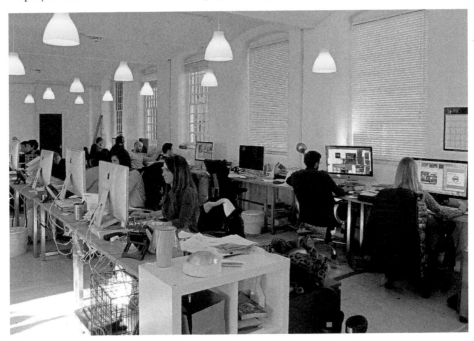

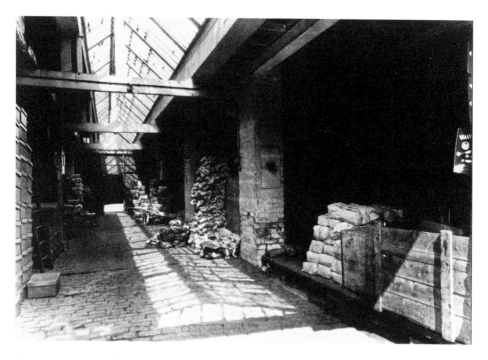

New Uses in the Mill Complex

Darley Abbey Mills are remarkable, not least because so many auxiliary buildings have survived, unique for a mill complex of this age. The building above may once have been stables and was at one stage a yarn store. It was certainly being used for storage by the time the photograph was taken around the time of the Second World War. Today it is used as premises for a sign-making company – Concept Visual Management.

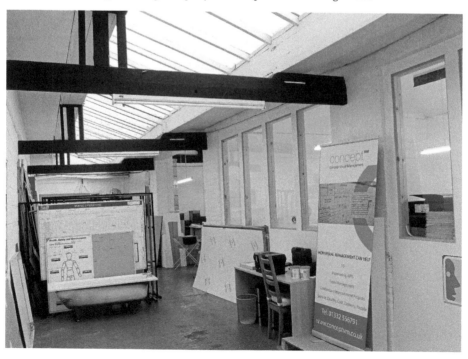

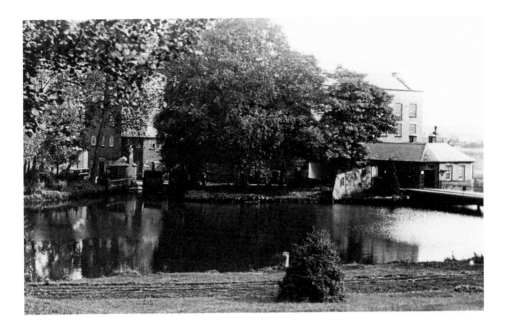

A Lost Water Channel

This unusual view of the Darley Abbey Mills from the north side of the bridge shows sluice gates by the little booth now known as the toll house, but probably at one time used by the site watchmen. These gates were to regulate a water channel, now filled in, which passed under and powered the West Mill (*on the right*). To the left of the booth is a parked car said to belong to John Peacock, who took over the mill business after Walter Evans died in 1903. The building on the right was the mill canteen, now an award-winning restaurant – Darleys.

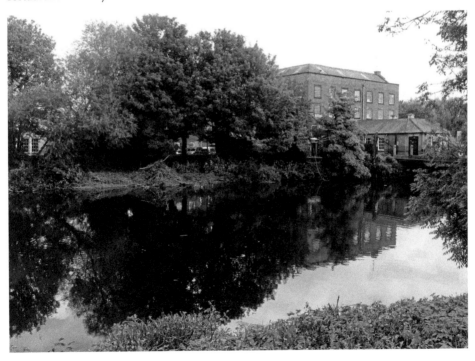

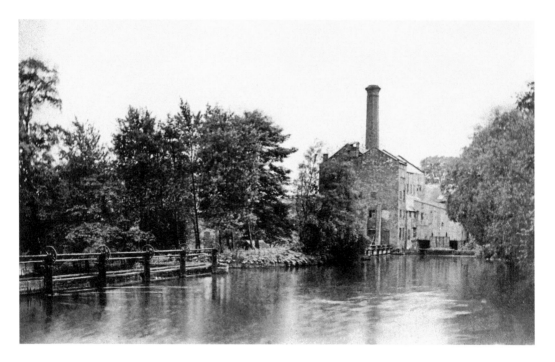

The Paper Mill

When the Evans brothers bought this site, south of the weir, in 1775, there were a number of mills here, producing paper and flour, among other goods. These mills continued to employ men, while women and children worked in the cotton mills. The paper mill (still standing in the older photograph, above) was demolished in the 1930s, and the land is now a field. A fish pass was built through the little island in the middle in 2013/14. Much effort was taken to minimise its impact on the setting of the mills – a letterbox-like slit over the water indicates its position.

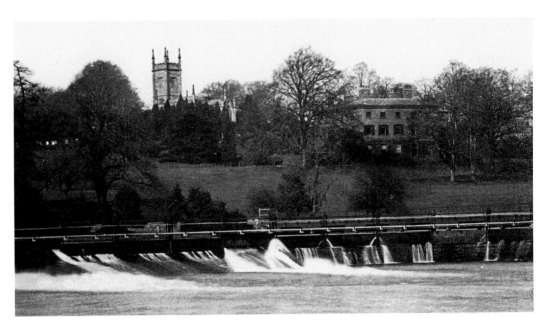

St Matthew's Church and Darley House

From the mill side, looking up past the weir, there's a clear view of St Matthew's church. Built in 1818/19, it was paid for by the Evans family with help from a grant, known as Queen Anne's Bounty. Darley House (in the older photograph) was built by William Evans *c.* 1785, but demolished in 1932, and the site used for housing. The removal of the sluice gates above the weir reduced the level of the water significantly, so it's much easier to see the bridge today.

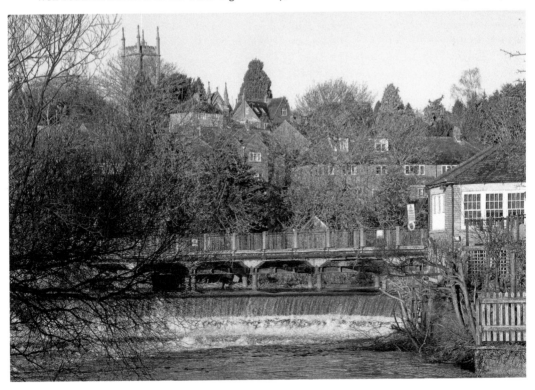

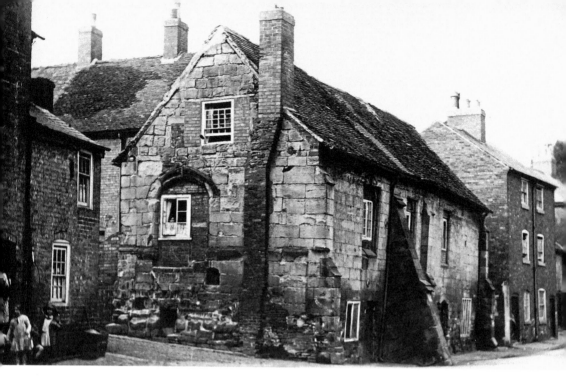

Remnants of the Priory

The Abbey Public House was once a building close to the medieval priory from which Darley Abbey takes its name. At one time it was purchased by the Evans family and housed millworkers. Considerable work was carried out in the 1970s to save the building from collapse before its new use as a pub was established from October 1979. Steps were recreated at this end so that the doorway could be restored and reused. The inserted brick chimney was removed.

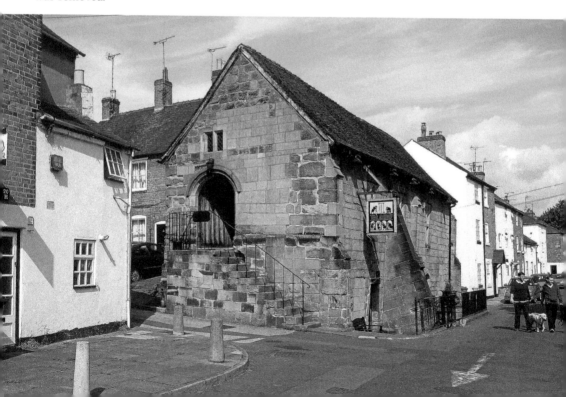

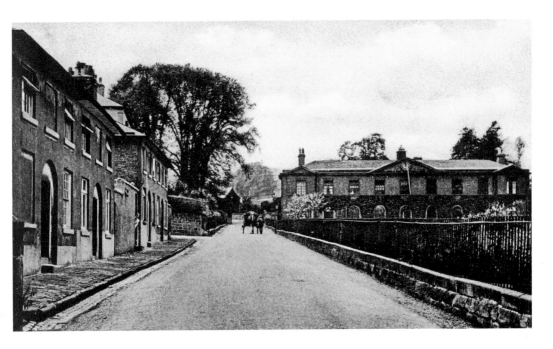

New Road and the School

These millworkers' houses on New Road in Darley Abbey were stylishly built as they could be seen from Darley House. The render on the two-storey buildings has been painted white since the earlier view. Parked cars have replaced the horse and cart. The building of flats on the site of the old allotments (*on the right*) gives the impression that the 1826 school on Brick Row has been demolished, but it's still there, hiding behind them (*inset*), although it no longer serves as a school.

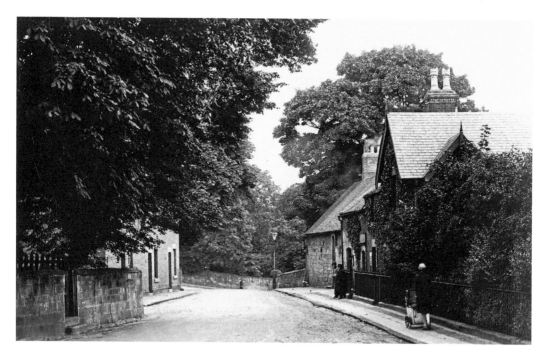

Abbey Lane

Before the Second World War, Abbey Lane looked to be a quiet, leafy village road through Darley Abbey. Since then, new buildings have been added, and the more mature trees have disappeared. The break in the wall on the left has been filled, and there have been changes to the roof of the building on the right, but it's the addition of so many cars that makes the greatest difference.

Darley Hall and Park

The Evans family purchased Darley Hall in 1835. The impressive grounds on the banks of the River Derwent provided the house with fine views of Derby. They were gifted to the town in 1929 and the hall purchased by the council in 1931. Although used as a school in wartime, the hall was demolished in 1962 (*inset*), except for the billiards room – a separate extension (*seen on the far left, below*), which is now a tea room. The views of Derby can still be appreciated from the terrace, which was built on the foundations of the hall.

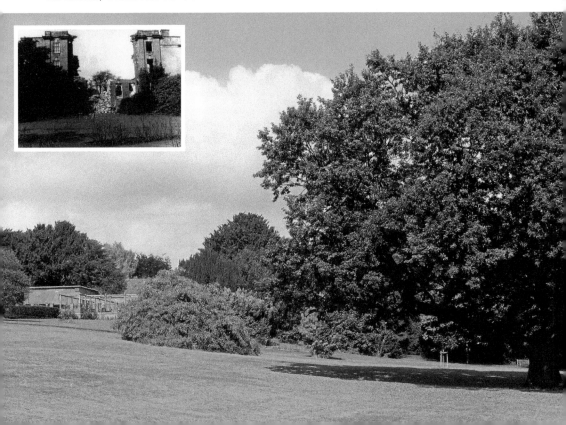

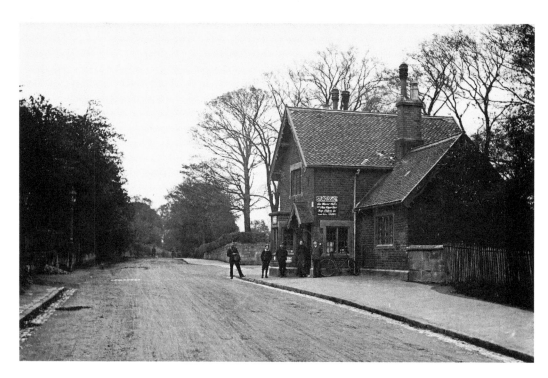

The Old Post Office

Where Mile Ash Lane returns us from Darley Abbey to the main A6 road, there was once a post office on the corner. A toll house stood at this junction, when the road was part of the turnpike. Now, there are no buildings on the site, but the sign shows you are entering Darley Abbey, one of the key World Heritage Site communities. It's much harder to take a photograph from the middle of the road today!

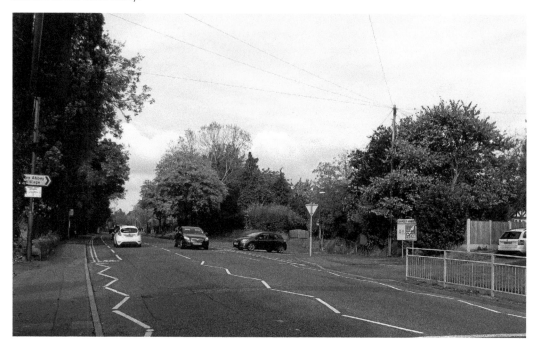

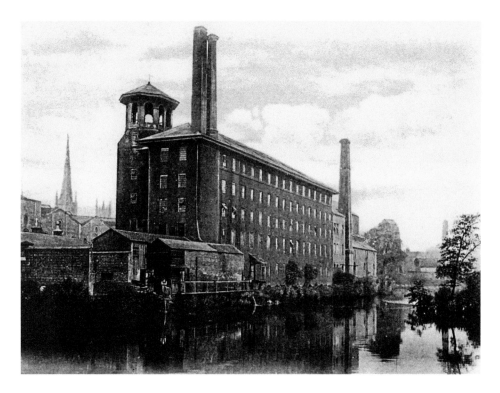

Derby's Silk Mill

The Lombe brothers' silk mill in Derby has undergone many changes in the past 300 years. As can be seen above, there were five storeys before the disastrous fire of 1910, which resulted in an almost complete rebuild. Of the original mill, only the arched foundations have survived. The mill's surroundings also look very different today – on the left, a blank wall hides a large electricity sub-station, where once, on the horizon, could be seen the spire of St Alkmund's church, demolished for a dual carriageway in 1967. Derby's Museum Trust has major plans for the future of the Silk Mill, subject to funding support.

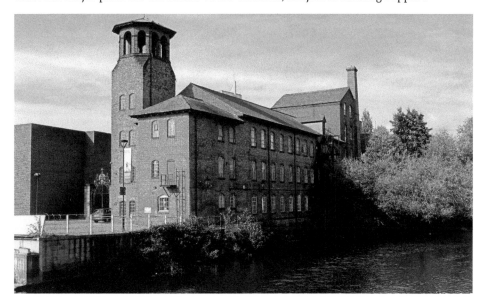

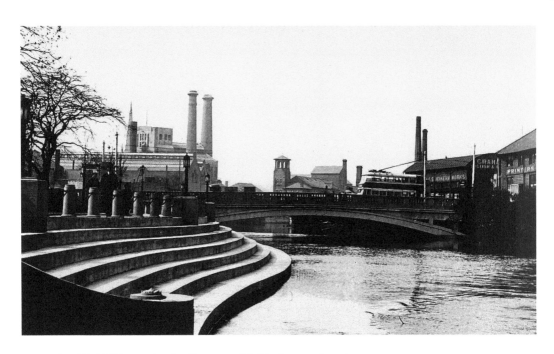

The Silk Mill from the Confluence with Markeaton Brook

Looking up river, back into the World Heritage Site, from where the Markeaton Brook runs into the Derwent, you could once see the Silk Mill on the far side of Exeter Bridge. A power station, larger than the mill's present neighbour, stood nearby, with distinctive twin chimneys. Today, the Silk Mill is hidden by trees and the Jury's Inn Hotel dominates the view. Trolleybuses came to Derby in 1932, but it's single-decker coaches on the roads these days. The Council House built in 1939–41 is on the far left of the modern view.

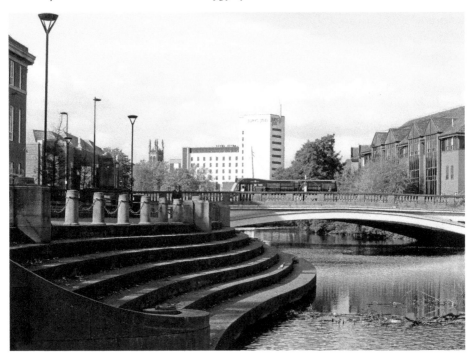